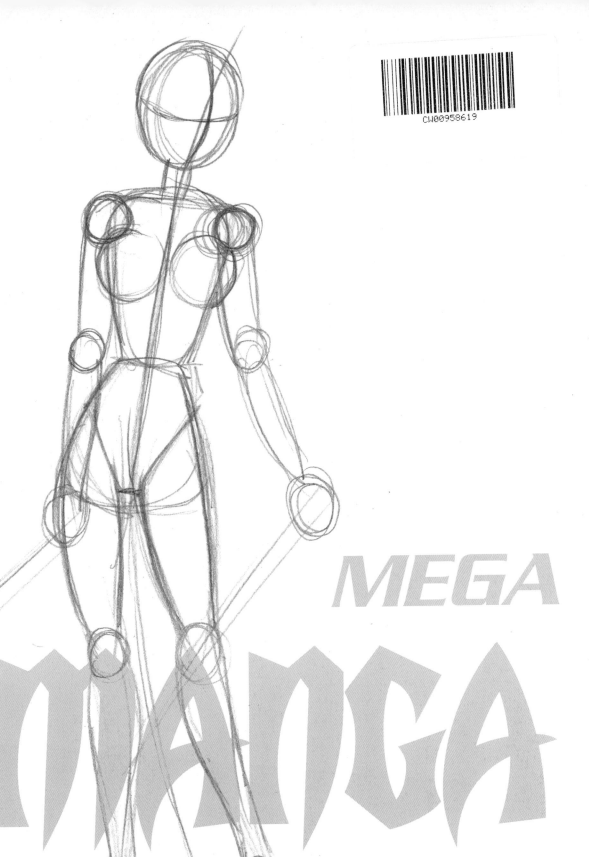

MEGA

MANGA

CHARACTERS

**First published in Great Britain 2021 by
Search Press Limited
Wellwood, North Farm Road
Tunbridge Wells, Kent TN2 3DR**

Original edition published in Spain **as Aprende a Dibujar
Personajes Manga by Parramón Paidotribo, 2018**
Copyright © 2018 Parramón Paidotribo

Text: Sergi Càmara
Illustrations: Vanessa Durán
Step-by-step exercises created by: Estudi Shinobi,
Lydia Tudela
Photography: Nos & Soto

ISBN: 978-1-78221-917-0

Suppliers
If you have any difficulty obtaining any of the materials and
equipment mentioned in this book, then please visit the
Search Press website for details of suppliers:
searchpress.com

Printed in Spain

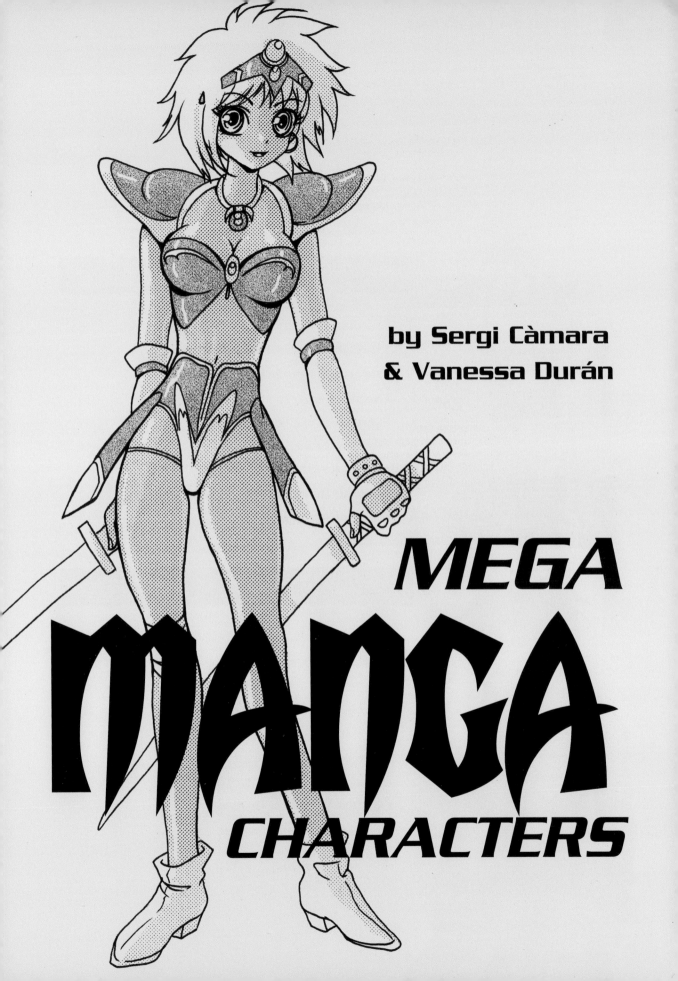

by Sergi Càmara
& Vanessa Durán

MEGA
MANGA
CHARACTERS

CONTENTS

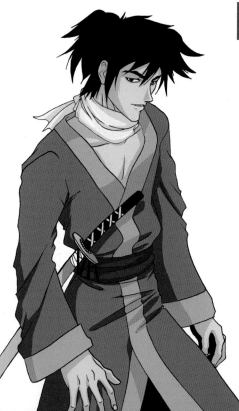

Shoujo characters 68

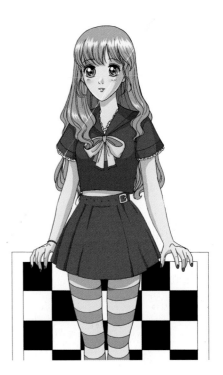

Seinen characters 98

Manga-style art

The fact that Manga has taken its rightful place as an important artistic technique in the Far East is beyond doubt. This art form with its stylization and serialized story format originated in Japan, where it also evolved into the audiovisual medium known as Anime. It is an important part of popular culture in Japan and reflects a panorama of different cultures across the Far East.

Initially Manga struggled to break through to a wider public outside of its native Japan. It was perceived by many as shocking because of the presence of adult themes ('stories full of eroticism and violence'). However, the gradual rise of Manga over time is proof that this varied medium caters for all tastes and ages. The surest sign of its growing influence is the fact that many Western artists and writers have adapted their own styles to incorporate some of the distinctive features of Manga – not only in an artistic sense, but also in terms of narrative.

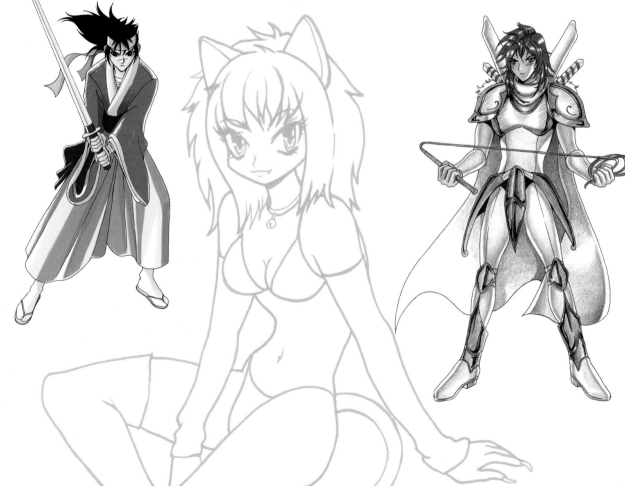

We have created the exercises in this book to demonstrate as clearly as possible how to reproduce the graphic fundamentals of the four main Manga styles: Kodomo, Shonen, Shoujo and Seinen. These are the subgenres from which more specialized fiction has evolved: Manga targeted at males, females, young people or a mature audience. The exercises in this book reveal the differences between the genres, how professional Mangakas work and easy-to-learn techniques which you can master with a little time and a lot of practice. Our aim is to make you feel comfortable enough to express yourselves in the Manga style. So… sharpen your pencils and begin your own personal Manga odyssey. Learn, grow in confidence and most importantly, have fun. Good luck!

Before you begin

You will need only a few tools and materials to get started: some pencils, an eraser and regular paper on which to sketch and design your characters. A quill pen, Indian ink and an absorbent cloth will be required for inking, and you will also need an assortment of coloured pencils to embellish your creations. Access to a computer with a digital graphics package would also be very beneficial.

Finding reference material will help you to get a better understanding of Manga before you start on your own stories. Many authors centre their Manga in everyday situations, so don't go too deeply into research, as you should remember to give your imagination free rein. Nevertheless, it's good to learn to observe details so that you can create a believable situation.

You need to prepare your paper and inks to ensure a successful application of wash techniques. Paper must be pre-stretched so that it doesn't become misshapen when you apply heavily diluted inks or washes. The easiest way to do this is to spray both sides and let the paper absorb the water for a minute. Then fix it to a piece of wood or hardboard with paper adhesive tape and leave it to dry completely (it will shrink and its surface will be firm).

In his famous 1437 treatise on painting, artist Cennino Cennini gave the correct proportions for diluting ink: 'Two drops of ink in a walnut shell filled with water.' This formula should always be considered as a starting point.

Also take some time to reflect on and pre-plan the distribution of light and shadow in your artwork, the final consideration when successfully working with washes.

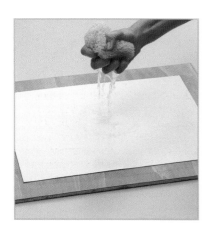

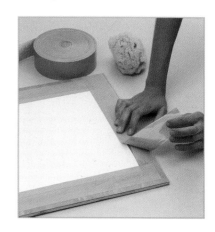

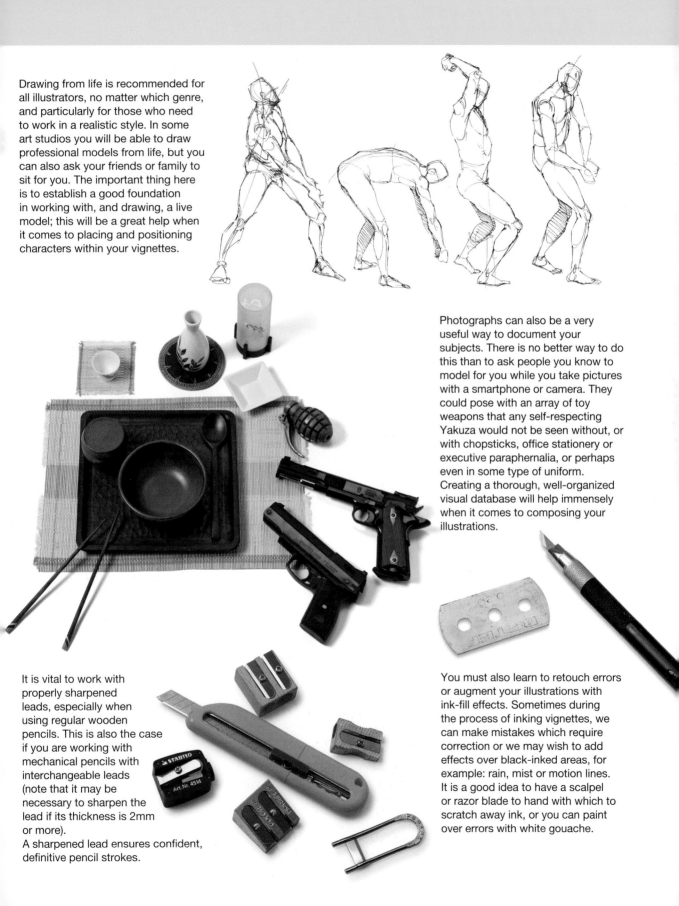

Drawing from life is recommended for all illustrators, no matter which genre, and particularly for those who need to work in a realistic style. In some art studios you will be able to draw professional models from life, but you can also ask your friends or family to sit for you. The important thing here is to establish a good foundation in working with, and drawing, a live model; this will be a great help when it comes to placing and positioning characters within your vignettes.

Photographs can also be a very useful way to document your subjects. There is no better way to do this than to ask people you know to model for you while you take pictures with a smartphone or camera. They could pose with an array of toy weapons that any self-respecting Yakuza would not be seen without, or with chopsticks, office stationery or executive paraphernalia, or perhaps even in some type of uniform. Creating a thorough, well-organized visual database will help immensely when it comes to composing your illustrations.

It is vital to work with properly sharpened leads, especially when using regular wooden pencils. This is also the case if you are working with mechanical pencils with interchangeable leads (note that it may be necessary to sharpen the lead if its thickness is 2mm or more).
A sharpened lead ensures confident, definitive pencil strokes.

You must also learn to retouch errors or augment your illustrations with ink-fill effects. Sometimes during the process of inking vignettes, we can make mistakes which require correction or we may wish to add effects over black-inked areas, for example: rain, mist or motion lines. It is a good idea to have a scalpel or razor blade to hand with which to scratch away ink, or you can paint over errors with white gouache.

KODOMO CHARACTERS

Throughout this chapter, we will study different examples of characters drawn in the Kodomo style, possibly the most playful Manga style, which was popularized in the Far East through television series such as Doraemon, Dr. Slump and Shin Chan.

The Japanese word 'kodomo' means 'child' and is an umbrella term for all Manga stories created for children. Its graphic style is humorous, simple and direct. The construction and representation of its characters is often not clearly defined and it is not uncommon to come across 'doodles' recognizable as the signature style of an individual artist. Kodomo themes and settings are developed around its characters' everyday lives with which younger consumers can identify.

The following exercises will help you to replicate some of the most important physical characteristics of the characters that feature in this popular Manga genre.

Girl in kimono

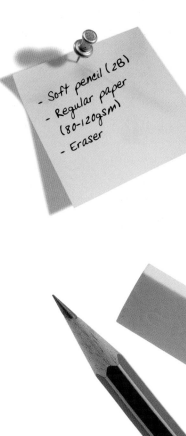

Let's start with a simple exercise: a typical Kodomo girl. In this exploratory exercise, we show you how to draw a static pose, because it is important to structure your character correctly and to make sure you include characteristics typical of this genre (for example, simple yet confident lines and big eyes). Here we will focus solely on working with a pencil, as we'll tackle more elaborate techniques such as inking and colouring in subsequent exercises. You will soon realize that it's not all that hard to get a very satisfactory final result.

1

Basic structure

Create a simple sketch scaled to the dimensions of your paper. You must establish the character's general proportions by drawing in a central symmetrical axis on the torso, a horizontal axis that indicates where her eyes will be positioned and the central vertical axis of her face.

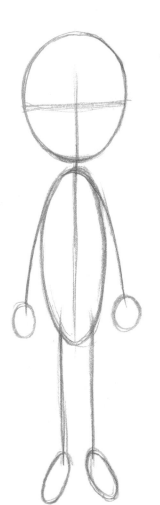

- Soft pencil (2B)
- Regular paper (80–120gsm)
- Eraser

It is vital to practise pencil drawing extensively so that you can sketch quickly and confidently.

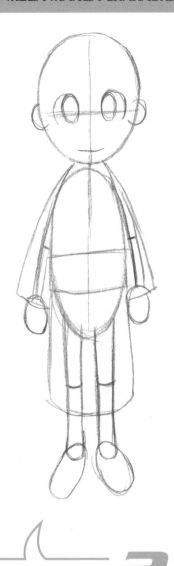

Include details and accessories

Check proportions before focusing on more anatomical detail and on clothes. At this stage you should produce a definitive illustration of your character and all of its accessories. You can be confident in your work because you have already established correct proportion, making it easy to add details to distinguish your character from others.

3

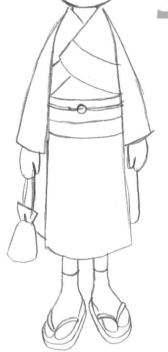

Complete the structure

2

Use the previous sketch to begin to add volume to your character, paying careful attention so that it is correctly proportioned (elbows, knees, and so on). Indicate generally where her dress and other items of clothing will be placed and sketch in the shape of her eyes.

4

Trace the outline in pencil

For this last step, position a clean sheet of paper over the top of your finished sketch and trace around the outline. If you do not have a light box, you can always use greaseproof paper. The aim here is to create a final drawing of your character that can be enhanced and finished with any technique that you wish to use.

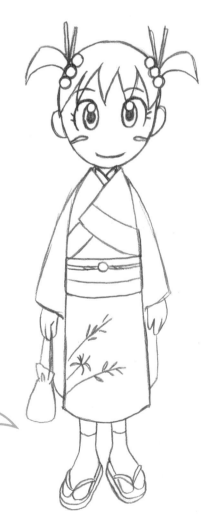

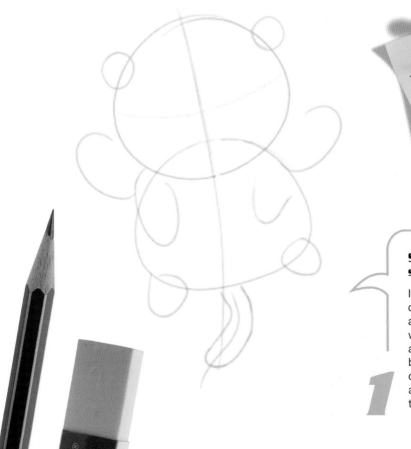

Exercise 2

Pet with superpowers

A nother common component of Kodomo Manga is a pet that accompanies the main character, normally possessing magical powers that open the door to endless incredible adventures. The aims of this exercise are the same as for Exercise 1: fluidity in your pencil movements and to familiarize yourself with some of the typical characteristics of this style.

- Soft pencil (2B)
- Regular paper (80-120gsm)
- Eraser

Structure using simple axes

It is standard practice to establish a character's proportions with simple axis lines. Marking out these axes will give your character stability and indicate where its arms should be positioned. For more complex characters, add shoulder and hip axes too: this will help you to create the correct overall proportions.

1

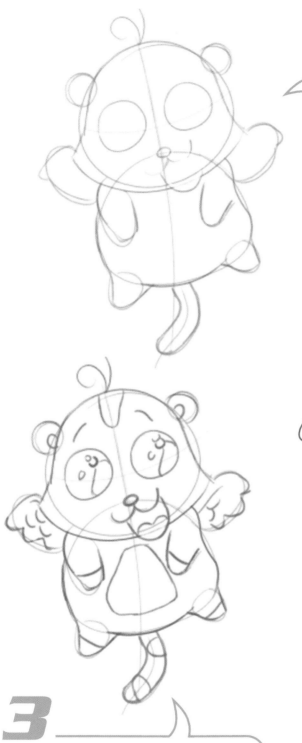

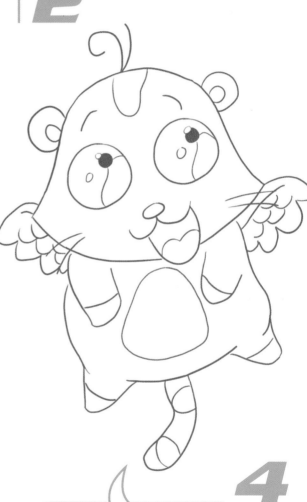

Creating volume

You can give volume to a figure through the use of circles and ovals. You already have the sketch you created in step 1 as a reference; now you can fill out your character by positioning the rest of its features.

2

Sketch in other details

Adding detail to this structure will bring your character to life: its eyes, nose, mouth, accessories, and so on, which should be positioned over the horizontal axis that you used to structure its face. This step may require several attempts because it is important to draw very accurately.

3

Reinforcing your figure

Thoroughly review your character's structure to check if it is correct and then begin to reinforce it. Your sketch will undoubtedly be covered with unwanted pencil marks, axis lines and the circles and ovals that you have used to create volume. Ignore these, using your pencil to reinforce only the lines that you will use in your final drawing. You must work carefully, with the same attention to detail as in step 3.

4

Sporty cat

I n this exercise we use screentones to create halftone areas, giving the character a finish worthy of any Manga comic book page. We also introduce a new way to finish off your characters. Using screentones is delicate and laborious work, but the excellent results are more than worth the effort. There are many different screentone formats on the market; traditionally a laminated, patterned adhesive film is used, which you position over the area to be covered and then trim with a scalpel (taking care not to damage the image underneath). Others are rubbed onto the paper as a transfer. However, perhaps the most commonly used screentone (and also the safest and easiest to apply) is created using computer software. Here we will start you off by using laminated adhesive film.

Designing the character

1

Take a fresh sheet of paper and ensure that your character is properly designed and correctly proportioned. Remember that at this point there is no need to draw details; if you concentrate instead on volume, proportion and stance, you will create a solid and effective structure.

- Soft pencil (2B)
- Tracing paper (120gsm or less)
- Eraser
- Inking tools: Indian ink, medium round paintbrush and laminated adhesive screentone to create a halftone finish (you will need three different patterns)

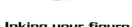

Details and accessories

Add features over the volumetric structure of the face. Note the importance of this character's expression, which represents a typical Kodomo style. Strengthen your figure's contours; the aim here is to produce a sketch that you can use as a foundation for the finished drawing.

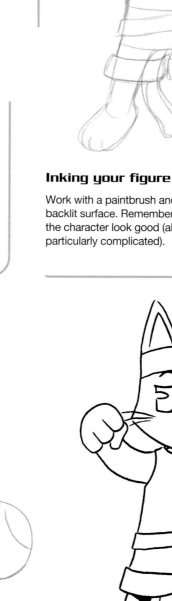

Trace over the sketch

Trace the entire figure with a soft pencil. We recommend a 2B, but some illustrators prefer a harder HB; you should experiment with both types and decide which is best for you. On this occasion do not shade darker areas with graphite because your figure must be transparent (unless the darker areas are very pronounced). Any pencil marks on the white of the paper will show through after you apply screentones.

Inking your figure

Work with a paintbrush and Indian ink on a light box or other backlit surface. Remember that good brushwork will really make the character look good (although in this case the figure is not particularly complicated).

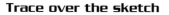

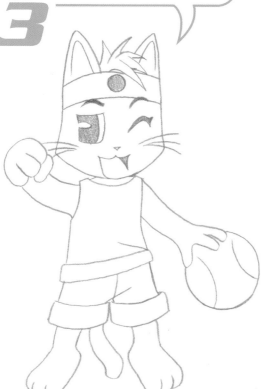

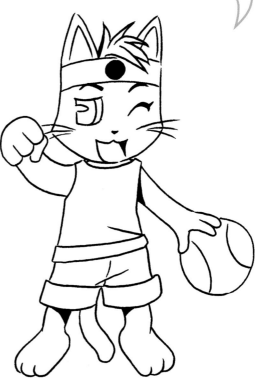

5

Applying adhesive screentones

Before you begin to apply your screentones, decide which of them you are going to use where on your character. Remove the protective film from one sheet of screentone and place it over the areas that you wish to cover (it should be slightly larger than these working areas). Use your pencil to trace around the lightest areas (head, arms, legs and tail), allowing you to create more complex designs. Next apply your first screentone (see step 6).

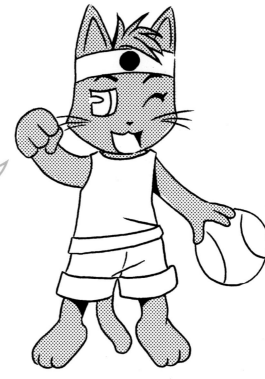

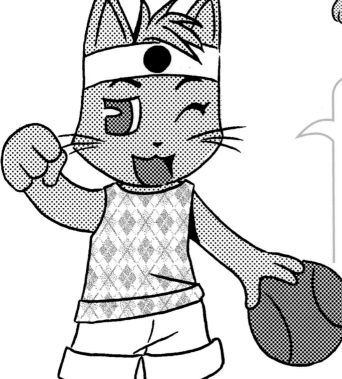

6

Cutting screentones

Using a very sharp scalpel (taking care not to damage the drawing underneath), cut out the shapes of the areas that you have decided to fill. After any excess screentone has been removed, you can stick the finished sections to your figure by placing a clean sheet of paper on top of the screentones and applying slight pressure with the palm of your hand. Use the same procedure to apply a darker screentone to your cat's eyes, mouth and ball, and finally your third screentone for his t-shirt.

If you decide to use laminated screentones, be very careful not to damage the paper underneath, and watch your fingers!

Exercise 4

Sushi characters

At first the design and development of a Manga character may seem easy (and in many ways, it is), but it does require a careful consideration of posture and facial expression. Sometimes even a simple character is the result of many hours of preparation as well as trial and error and artistic skill. In this exercise we will use coloured pencils to achieve a simple effect similar to the characters that we have looked at so far.

Character design

We are jumping straight to the stage when a character is already designed and drawn and its axes and construction lines have been removed. Note that these two sushi figures are three-quarter lit and in perspective; you can create fully three-dimensional images if you work things out beforehand.

1

- Soft pencil (2B)
- Eraser
- Marker pen for inking
- Special (porous) paper for coloured pencils
- Coloured pencils (36 colours)

The inking process

Strengthen the lines on both characters with a medium/thick marker pen (minimum 8mm nib). Use permanent ink if possible as it dries quickly and does not smudge. As you can see, the only ink-filled areas on these two characters are their eyes.

2

3

Applying a colour base

Gently apply a faint, first-draft colour base, remembering to consider from which direction the light strikes your character and which areas will be darkest.

Using shadow to create volume

Apply a greater colour intensity to darker areas, creating volume. Note that your pencil strokes should be diagonal, superimposed over the previous base colour layer. Intensify some of the darkest areas (such as the arms and feet) by making tiny spirals with the tip of your pencil.

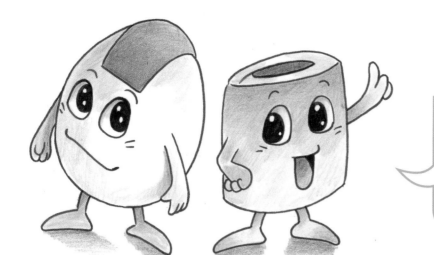

Cast shadows

5

Shading for cast shadows must be simple but effective so the characters do not appear to float above the surface of the paper. Shade using zigzag movements with your coloured pencils.

Kodomo-style Manga allows you to experiment with new characters. Let your imagination run wild!!

6 ### Finishing touches

Finally, embellish the figures with other details. Here we have included red spiral patterns which could represent different things depending on the context of your work.

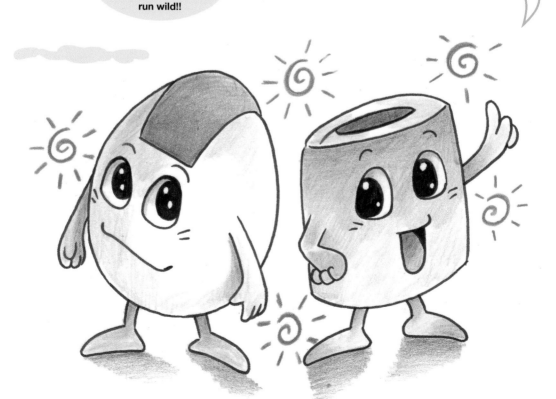

1960s retro pixie

This exercise introduces two new skills: inking a character in different colours and highlighting it with tempera or gouache paints. Both techniques allow us to apply spot colours and bright, intense tones. The secret of both of these techniques is to keep the tip of your paintbrush loaded with colour and apply it carefully. Note that the more water you mix with your paint, the more like watercolour the results will be. The fundamental difference is that gouache and tempera colours should be kept more opaque, so if you apply one colour over an already dry layer, you can cover it almost entirely.

- Soft pencil (2B)
- Tracing paper (120gsm or less)
- Eraser
- Inking utensils: waterproof marker pens with 8mm nibs in sepia and black
- Tempera or gouache paints
- Watercolour paintbrushes

Final tracing

Here we start with a clean drawing that has been perfected in pencil. The design, structuring and reinforcement processes have been established in earlier exercises, and it is important to follow them step-by-step so that the figure you get down on paper is as close as possible to the result that you have in mind.

1

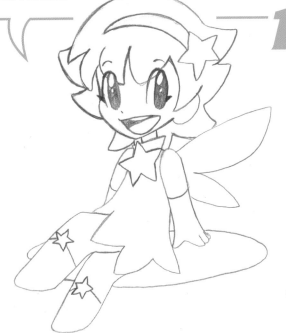

Exercise 5

2

Inking with different colours

Ink the figure, using sepia for all the lines except those around the eyes, which you should ink with black to make them stand out from the rest of her features. Use your marker pens confidently and without hesitation. Keep your lines consistent, otherwise the final result can be adversely affected. Of course, you could always use a medium other than marker pen; it's always good to practise different inking techniques.

> Inking in multiple colours gives your characters a much softer appearance. Try this wherever you think it might be effective.

Applying a base colour to her clothes

Remember that your spot colours will only be effective (opaque or bold) if you load your paintbrush with the correct solution of water and gouache; it must not be too heavily diluted or too thick. Paint one area and leave it to dry before applying a new colour.

3

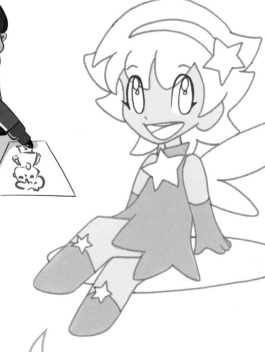

4

Applying a base colour to her skin

Repeat the process detailed in step 3. Remember to let the inked lines guide your work; i.e., try not to overlay and blur them with layers of colour. If you see that this is going to be difficult, you can always choose to apply colours first and ink the lines once your gouache is completely dry.

Colouring the rest of the character

Complete the colouring process. Try to choose colours that contrast with her dress, as this will make the finished article more attractive. You can also work in a range of shades of the same colour and, although the result will be less varied chromatically, you can still achieve an engaging end result.

5

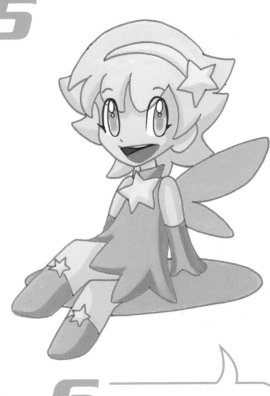

6 ### Using shadow to create volume

Always remember that gouache is a screening layer. This means that if you want your shading to stand out, you must use a slightly darker layer of the base colour. You can also use the same base colour with other techniques (such as watercolour), but you may need several applications to achieve this darkening effect.

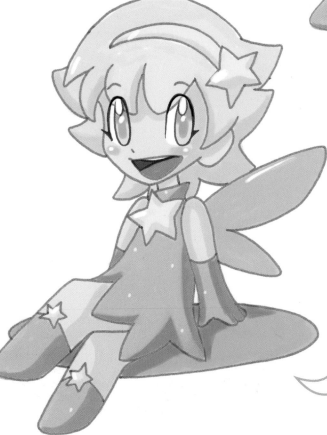

7

Finishing touches

To further enhance and add more volume to the character, apply some lighter tones over the areas you have already coloured. Use a paintbrush and white gouache, taking great care which areas you choose to apply these finishing touches.

Little prince

Here we show you how to use a computer to finish your artwork. Initially you will need access to any device that has art software installed and a flatbed scanner to digitize your drawings from paper. In this exercise we will work on a little prince, a recurrent character in Kodomo Manga stories.

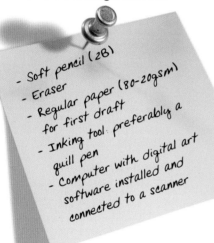

- Soft pencil (2B)
- Eraser
- Regular paper (80-20gsm)
 for first draft
- Inking tool, preferably a
 quill pen
- Computer with digital art
 software installed and
 connected to a scanner

1

Pencil drawing of the character

As the design and construction of your character has been covered in previous exercises, we will jump straight to the stage where you have completed your line drawing. Now the figure is ready to be inked.

Exercise 6

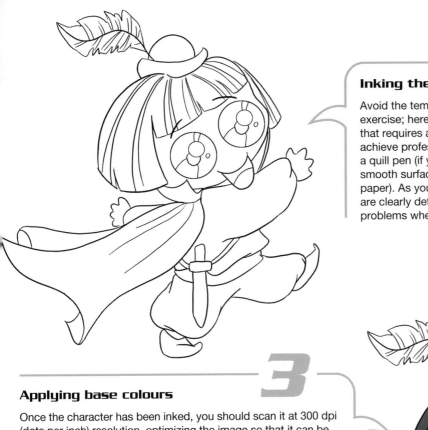

2

Inking the character

Avoid the temptation to ink with marker pen for this exercise; here you are working with a new technique that requires a different approach if you wish to achieve professional results. The ideal inking tools are a quill pen (if you have chosen to use a paper with a smooth surface) or a paintbrush (with rough-textured paper). As you ink your drawing, ensure all the lines are clearly defined, as this will help you to avoid any problems when applying colours.

3

Applying base colours

Once the character has been inked, you should scan it at 300 dpi (dots per inch) resolution, optimizing the image so that it can be manipulated in any digital medium. Even the simplest graphics program on the market has a 'paint fill' tool; simply mouse click on the desired area and select a colour to fill it. Each area of your character must be perfectly outlined and enclosed, otherwise colours will permeate other sections.

4

Shading

Use the 'pencil' tool to select areas that you wish to shade. Always shade a character's features on the opposite side to where you have decided the light is coming from. Correct shading always brings more volume to your figure.

Exercise 6

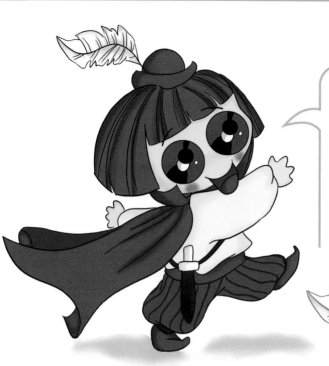

5

Fading shadows and darker areas

Shading in sharply defined blocks is not a problem; in many cases this is the technique to use. However, for this exercise we suggest that you apply fades to blur the transition between different tones, adding more of a sense of volume to your figure. If your graphics program allows it, do it! It really is as simple as selecting the amount (percentage) of fade required.

6

Using digital art software to work on bright areas

Repeat steps 4 and 5, but this time on your character's brighter areas. Setting the correct levels of brightness and fade will make a big difference to your character's appearance of volume.

7

Finishing touches

You can enhance your end result even more. One way to do this is to add different colours to your previously inked demarcation lines; while outlining in black is considered standard and will deliver excellent results, sometimes you may want either to use the illustration for a comic book cover or to experiment with new tools and techniques. It's simply a matter of experimenting with such effects and learning from your experiences.

Robot warrior

Here we use the same techniques as in the previous exercise to create a very different type of character, still considered to be Kodomo style but with a higher level of realism. Again you will work with a computer, but here we introduce a new approach to applying light and shade. One great advantage of working digitally is that there are multiple procedures that you can use to achieve the same effect; thoroughly explore the options that your software offers and don´t worry about making errors as they can always be corrected. You can backtrack to previous steps or even return to your original and start again from scratch.

- Soft pencil (2B)
- Eraser
- Regular paper (80-120gsm) for first draft
- Inking tools: calibrated black marker pen with 5-8mm nib
- Computer with digital art software installed and connected to a scanner

Pencil drawing

1

As in previous exercises, begin to work from your completed pencil drawing. Because it has not yet been inked and isn't your definitive version, you can use it to practise locating shaded areas, giving you an approximation of what your final illustration will look like.

Exercise 7

2

The inking process

Ink the character with your calibrated marker pen, though any medium will work well if properly applied.

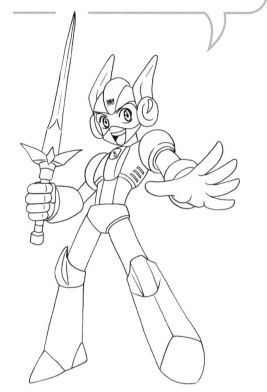

3

Scan the original

As we mentioned in Exercise 6, scan your original illustration at 300 dpi or higher for the best results. It is advisable to use grayscale at this stage, then a colour mode once it is onscreen: RGB if your work is going to appear online (web, blog, and so on) or CMYK if you plan to circulate your artwork via any printed media.

First base colour

Use the 'paint fill' tool to apply the first of the base colours. Don't forget how important it is that all your inked lines perfectly enclose the areas chosen so that colours don't permeate other areas of your illustration.

4

5

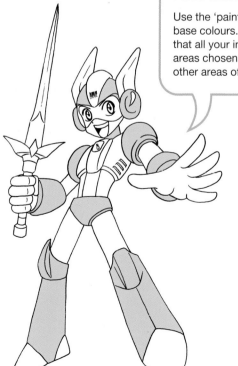

Second base colour

Apply the second of the base colours by repeating the process in step 4. You could always use the 'magic wand' tool to select the area that you wish to colour; while this is not strictly necessary at this stage, we will use it to shade our character later in this exercise.

6

Base colours for skin and accessories

Use the 'paint fill' tool again by clicking on the areas you wish to colour. Try to achieve an aesthetically pleasing overall colour scheme.

A tablet pen will help you to achieve a more precise finish; there are many inexpensive models available.

7

Shading

Here we ask you to select one of the areas that you want to shade and use the 'magic wand' tool to do it. Select a new colour tone and apply it where necessary, using the 'airbrush' tool. This gives you total control over the areas that you wish to shade, as the airbrush will not deviate from the selected area, always colouring inside it and always with the intensity that you choose. Repeat this process wherever you want to apply shading.

8

Brighter areas

Some graphics software allows you to save previously created selections. If your software offers this option, you can revisit your previous selections and perform the same processes that you used to shade your figure, but in brighter areas. Don't forget to apply brighter areas as new layers. Finally, once you are satisfied with the result, integrate the different layers and save the original.

Magical playing card champion

I n this exercise you will create a colour illustration using marker pens, a technique that offers many possibilities. When marker colours are applied well, the results are amazing and the finishes stunning. There are many brands on the market and, while the most expensive are not necessarily the best, markers that are commonly found in the classroom will not allow you to achieve a proper finish. We suggest that you experiment with different brands until you decide which of them best suits your artistic requirements and your budget.

- Soft pencil (2B)
- Eraser
- Regular paper (80-120gsm) for first draft and 120gsm or above for inking
- Inking materials: waterproof black marker pen
- Felt-tipped coloured marker pens or a paintbrush

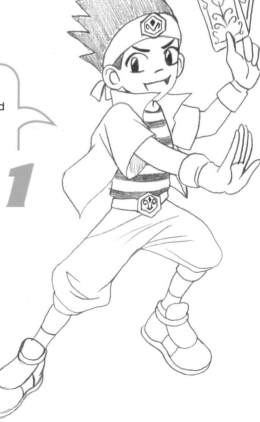

Pencil drawing

As usual, design, structure and scale your figure, add detail and strengthen its outline.

1

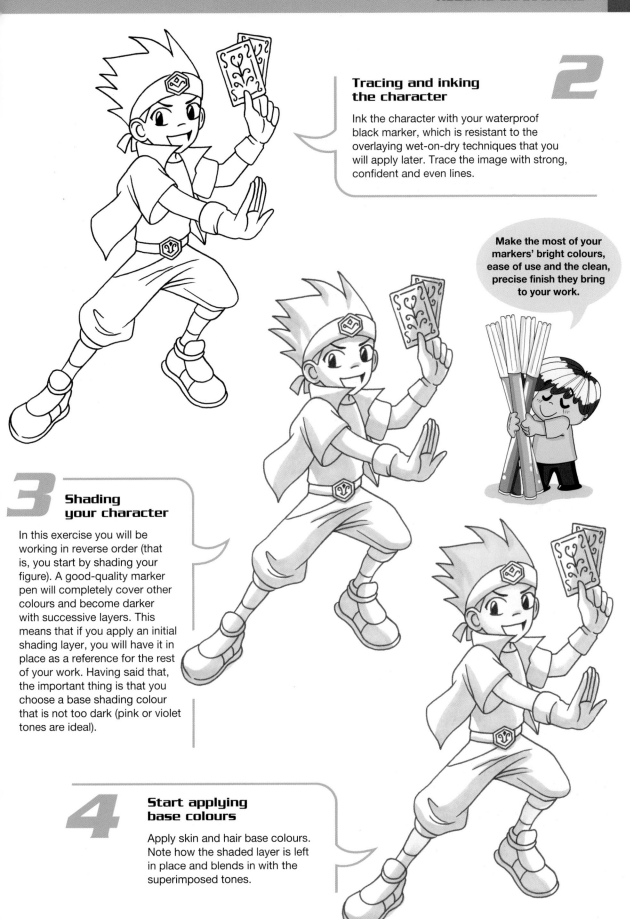

2

Tracing and inking the character

Ink the character with your waterproof black marker, which is resistant to the overlaying wet-on-dry techniques that you will apply later. Trace the image with strong, confident and even lines.

Make the most of your markers' bright colours, ease of use and the clean, precise finish they bring to your work.

3

Shading your character

In this exercise you will be working in reverse order (that is, you start by shading your figure). A good-quality marker pen will completely cover other colours and become darker with successive layers. This means that if you apply an initial shading layer, you will have it in place as a reference for the rest of your work. Having said that, the important thing is that you choose a base shading colour that is not too dark (pink or violet tones are ideal).

4

Start applying base colours

Apply skin and hair base colours. Note how the shaded layer is left in place and blends in with the superimposed tones.

5

Apply a colour base to the clothes

Repeat step 4, colouring your figure's clothes. It doesn't matter if you use dark colours as their application will still integrate with your original base shading colour.

6

Accessories

Continue by filling in other areas with your marker pens, selecting colours that are appropriate to the rest of the figure. Use the same techniques as described in steps 4 and 5, but here you are colouring the figure's accessories rather than applying base colours, so use colours that highlight and bring personality to your work.

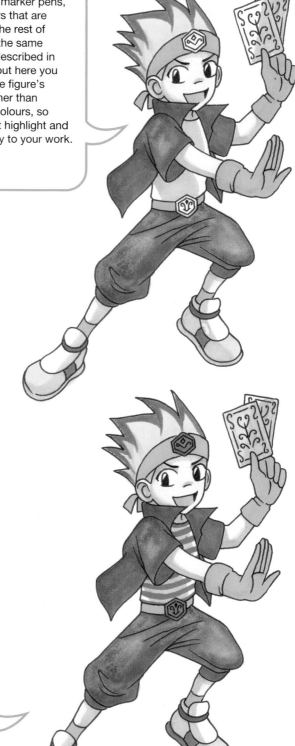

7

Defining details

Review your work up to this point. Check it several times to make sure that all the elements are properly drawn and detailed and of sufficient quality. If you want to highlight a particular detail or you can think of anything that will make your final illustration more attractive, do it!

Exercise 8

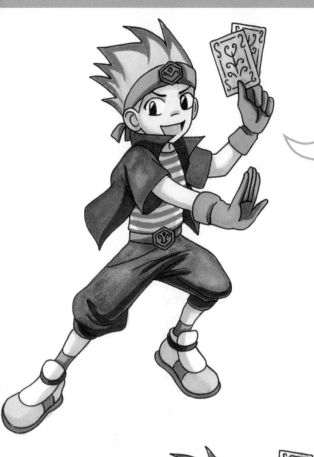

Redefining shaded areas

8

You may have applied more colour than you meant to over shaded areas – indeed they may even have disappeared entirely. Contrast is very important in a finished piece of work, so now is the time to darken shaded areas and make your figure more aesthetically pleasing. Here you should apply a fresh layer the same tone as the base colour or alternatively use another colour, darker than the base colour.

Cast shadows

While it may seem unimportant (and in practice it is not always necessary), a shadow cast onto the ground, a wall or other background elements will make a character much more realistic. In this case a simple shadow underneath the figure indicates its position relative to the ground, an important part of the finishing process.

9

10 ## Finishing touches

Adding highlights with a fine paintbrush loaded with tempera or gouache will enhance the figure and give it more volume.

Exercise 9

Boy with pet

A child accompanied by a pet or companion is a common character in Kodomo Manga. You will be working digitally again. While the steps you must follow are very similar to those in Exercise 7, you will not use fading effects on lighter or shaded areas, but applying these effects over sections filled with single colours.

- Soft pencil (2B)
- Eraser
- Regular paper (80-120gsm) for first draft
- Inking utensils: calibrated black marker pen with 5-8mm nib
- Computer with digital art software installed and connected to a scanner

1 Pencil drawing

Our starting point is a finished pencil drawing that includes some experimental shading effects. Remember that all details must be clearly present at this point, as the next stage is inking.

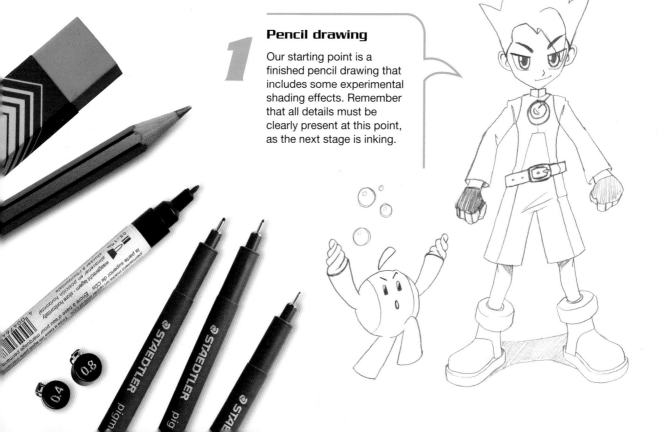

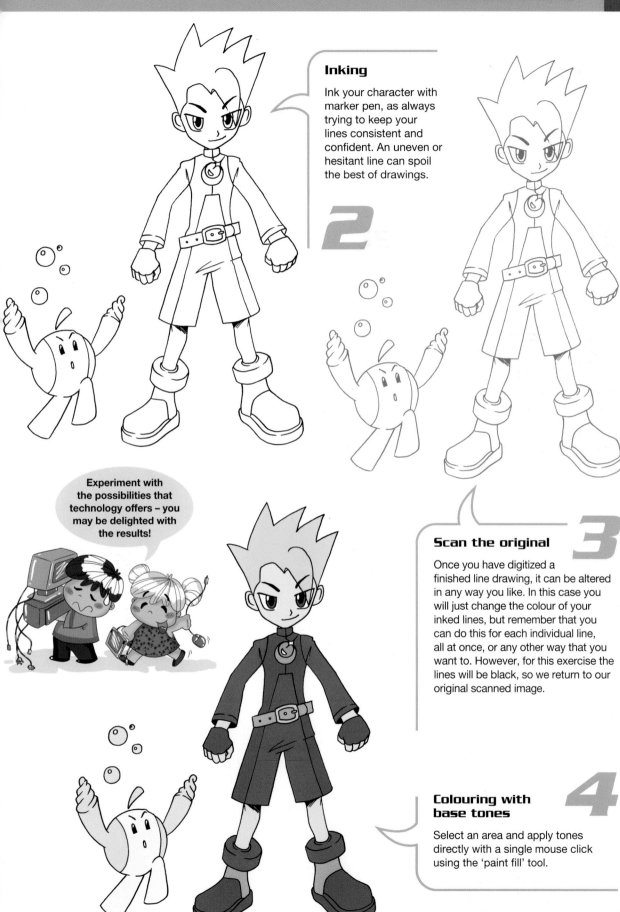

Inking

Ink your character with marker pen, as always trying to keep your lines consistent and confident. An uneven or hesitant line can spoil the best of drawings.

2

Scan the original

3

Once you have digitized a finished line drawing, it can be altered in any way you like. In this case you will just change the colour of your inked lines, but remember that you can do this for each individual line, all at once, or any other way that you want to. However, for this exercise the lines will be black, so we return to our original scanned image.

Experiment with the possibilities that technology offers – you may be delighted with the results!

Colouring with base tones

4

Select an area and apply tones directly with a single mouse click using the 'paint fill' tool.

Shading

5

Next select each area that you wish to shade and apply tones with the 'magic wand' tool. This time use a normal 'paintbrush' tool instead of the airbrush; there will be a selection of different paintbrushes in your graphics package. The result is different from Exercise 7, as this time shaded areas are not airbrushed but appear as blocks, giving a different look to the overall figure.

Apply one area at a time

6

Remember to select one area at a time before applying your shading effects and moving onto the next one. The 'magic wand' tool allows you to colour only the inside of the selected area, while other areas remain the same. This is ideal when you are colouring a very specific area or when you do not want to colour a line or any other sections of your image.

Final shading

7

In the previous steps you shaded individual areas. First the skin, then the red part of the boy's clothing; now it is time to shade the blue areas. Remember that it is important to select only those areas that you wish to shade, to avoid affecting the others.

Kodomo Manga is mainly for children, hence its use of bright, eye-catching colours.

Exercise 9

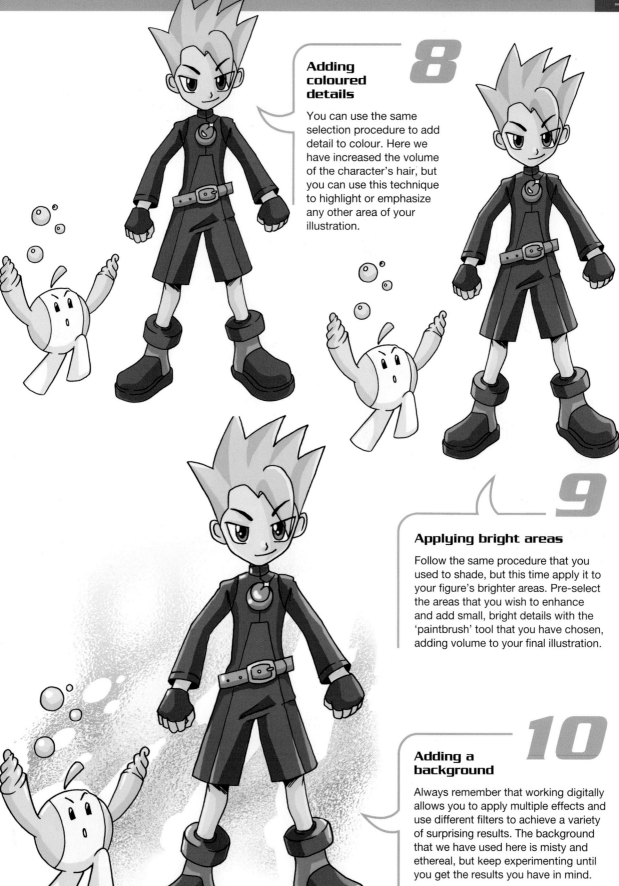

8 Adding coloured details

You can use the same selection procedure to add detail to colour. Here we have increased the volume of the character's hair, but you can use this technique to highlight or emphasize any other area of your illustration.

9 Applying bright areas

Follow the same procedure that you used to shade, but this time apply it to your figure's brighter areas. Pre-select the areas that you wish to enhance and add small, bright details with the 'paintbrush' tool that you have chosen, adding volume to your final illustration.

10 Adding a background

Always remember that working digitally allows you to apply multiple effects and use different filters to achieve a variety of surprising results. The background that we have used here is misty and ethereal, but keep experimenting until you get the results you have in mind.

SHONEN CHARACTERS

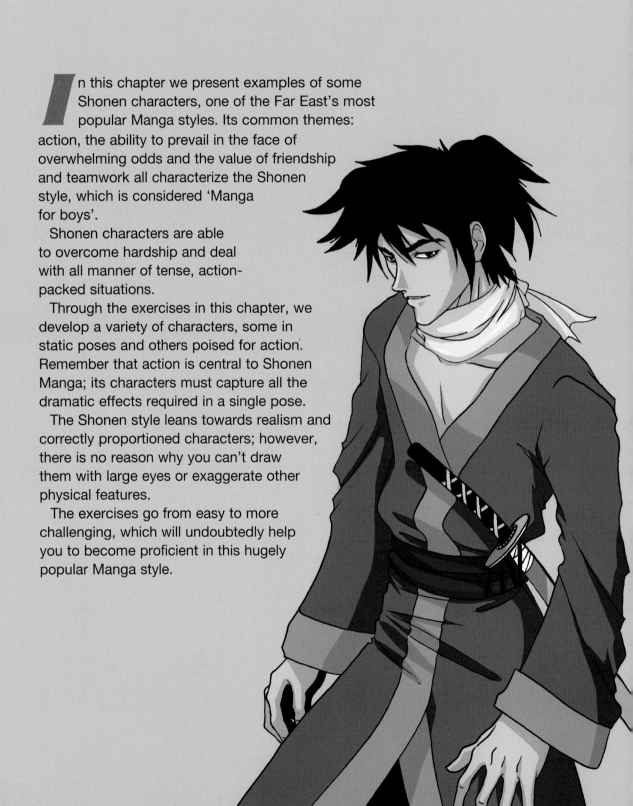

In this chapter we present examples of some Shonen characters, one of the Far East's most popular Manga styles. Its common themes: action, the ability to prevail in the face of overwhelming odds and the value of friendship and teamwork all characterize the Shonen style, which is considered 'Manga for boys'.

Shonen characters are able to overcome hardship and deal with all manner of tense, action-packed situations.

Through the exercises in this chapter, we develop a variety of characters, some in static poses and others poised for action. Remember that action is central to Shonen Manga; its characters must capture all the dramatic effects required in a single pose.

The Shonen style leans towards realism and correctly proportioned characters; however, there is no reason why you can't draw them with large eyes or exaggerate other physical features.

The exercises go from easy to more challenging, which will undoubtedly help you to become proficient in this hugely popular Manga style.

High school boy

In this simple exercise you will draw a classic Shonen character: a good-natured, nonchalant teenager. You will see how his static pose is achieved through a very simple design process. The important thing is to create the right structure and embellish it with some typical Shonen characteristics (floppy hair, large eyes, and so on). We only deal with a pencil sketch at this point; inking and colouring will be detailed in subsequent exercises. You will soon find out that it is easy to achieve excellent results!

- Soft pencil (2B)
- Regular paper (80-120gsm)
- Eraser

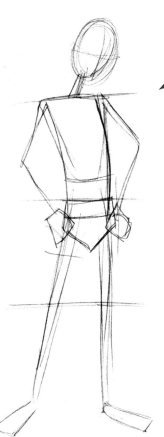

Basic structure
1

Make a very quick, simple sketch scaled to your paper. Be sure to correctly proportion your character by plotting four equal axes and an action line that determines his pose.

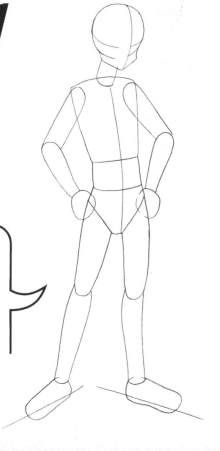

Character design
2

Draw circles and ovals over your initial sketch, adding volume and further defining its proportions.

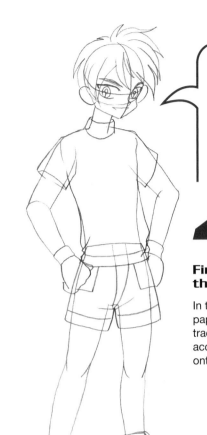

3 Add details and accessories

Once you have finalized your figure's structure, check that its proportions are correct and then suggest detail such as eyes, nose and mouth. Move on to the hands, knees, elbows, face, and so on, before sketching his clothes and shoes.

4 Finalizing and tracing the figure

In this final step, place a clean sheet of paper over your first-draft sketch and trace it. Remember that if you do not have access to a light box, you can always trace onto greaseproof paper.

Symmetry is vital when drawing heads. See below for in-depth advice.

The character's head

Structuring the head

The key to an expressive character is its face. Structure the skull and jaw line, creating axes which bring symmetry to the face and which will guide you as you place the eyes, nose, mouth and other features.

Placing details

Use your axes to give you an idea of where to place your character's features, including hair. Check your sketch to ensure that the face and its features are properly scaled.

Retouching and reinforcing

Retouch details and then begin to reinforce the different elements to finalize your sketch.

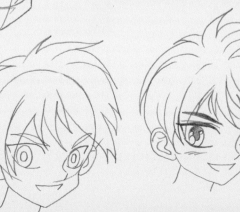

Basketball player

The aims of this exercise are similar to those of Exercise 10, but here you will draw a figure in a dynamic, all-action pose. It is important that the character is balanced on its axes, communicating stability and conviction. It is essential to draw an action line that will serve as a guide when constructing the rest of the figure, because you will also use it as a reference to sketch a basic framework.

- Soft pencil (2B)
- Regular paper (80-120gsm)
- Eraser

1

Creating structure over the action line

The action line denotes a movement dynamic and is used as a reference to correctly proportion a moving figure. Plotting axes in perspective corresponding to the three-quarter view of this figure brings balance to its pose.

Creating volume

2

Plotting circles and ovals gives volume to the figure. In this case the axes you draw must be true to the perspective in which you have drawn the character.

Sketching details

3

Start to draw in details over the finished structure, giving your character personality: his eyes, nose, mouth, hair, and so on. Observe the perspective of the face and place features according to your axis. This may require several attempts, but it is very important to achieve the correct perspective before you move on to the next step.

Practise sketching circles and ovals until you can draw them accurately in one go.

4

Refining and reinforcing

Check the structure of your figure thoroughly to ensure that everything is in place and it is drawn correctly. Decide which of its lines you will need to keep and which are superfluous. Your sketch will probably contain duplicate or multiple approximate strokes and lines; erase these and reinforce lines that you will use for your final version.

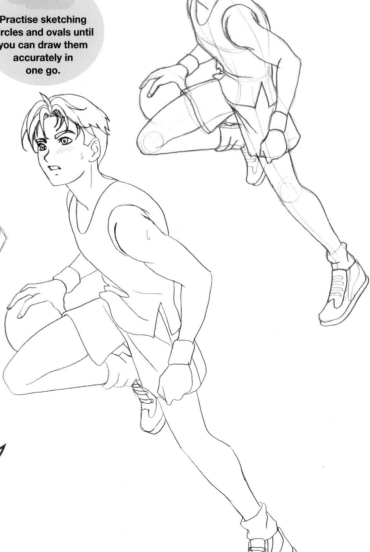

Youth with superpowers

In this exercise you will learn how to draw a youth with superpowers. The objective is to achieve a clean, professional finish. Access to a light box would be helpful, as all the guide lines drawn during your rough sketch must be eliminated before you produce the final version of your character. While pose and design are also important, strong and confident pencil lines will always help when it is time to ink your character.

- Soft pencil (2B)
- Regular paper (80-120gsm)
- Tracing paper (120gsm or less)
- Eraser
- Light box

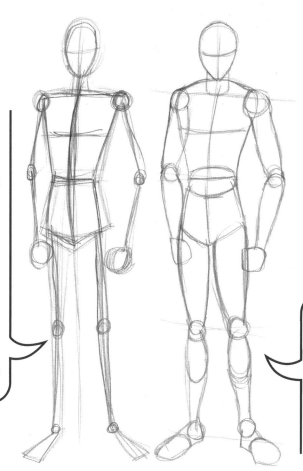

1

Creating structure

Create the standard first-draft sketch, establishing your character's dimensions so that they fit inside the space, perhaps a sheet of paper or a vignette. You must position the axes properly (which will help you to get the proportions right), as well as the action line (which marks out the dynamics of the character's pose).

2

Work on volume and proportion

This character's head is angled down slightly towards its torso, presenting a three-quarter view. Mark out the different ovals that comprise its overall structure, emphasizing the axes that define this subtle perspective and give it an intriguing and somewhat sinister appearance.

Placing details

3

Work out where to place facial features and expression, clothing folds, buttons, and so on. Decide which details and accessories you will include and place them accurately. In step 4 you will clarify them and add further detail, but the aim here is to place and scale them, ensuring that they correspond to the perspective that you have established with your axes.

Clarifying the figure

4

Work on the figure's outline with more lines, enhancing its dimensions. Finish placing details, which must now be drawn accurately. When this step is complete, your character should be perfectly defined; the work that you do now is geared towards producing a good finished article.

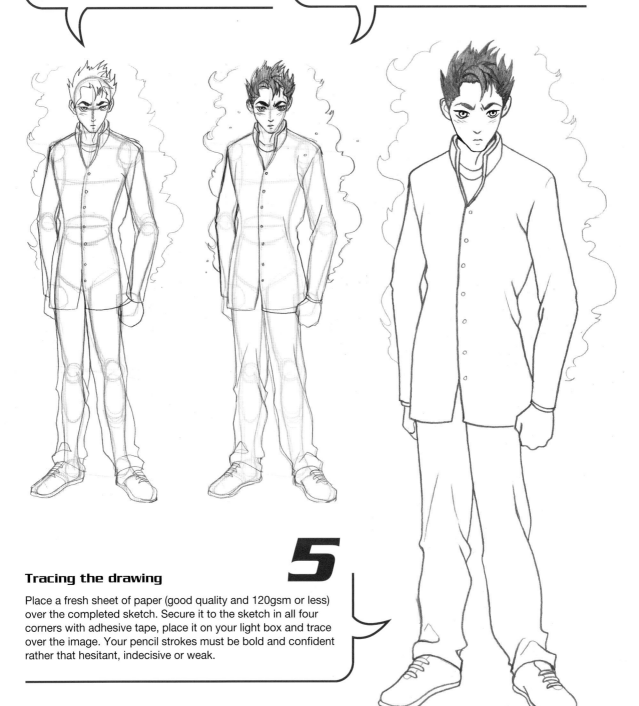

Tracing the drawing

5

Place a fresh sheet of paper (good quality and 120gsm or less) over the completed sketch. Secure it to the sketch in all four corners with adhesive tape, place it on your light box and trace over the image. Your pencil strokes must be bold and confident rather that hesitant, indecisive or weak.

Cat woman

In this exercise you will draw a Kemono (a human-animal hybrid), which is another character synonymous with Shonen Manga. We have chosen a 'cat woman', typically characterized by her sensual form and the shape of her eyes in addition to the basic concepts that we have explored so far (structure, volume, pose, proportion, and so on). To further your learning, you will finish this character with a simple, alternative inking technique that does not employ shading or semitones; the aim is to achieve a result as good as a finished drawing in soft pencil.

- Soft pencil (2B)
- Regular paper (80-120gsm)
- Tracing paper (120gsm or less)
- Eraser
- Inking utensils: marker pens, stylograph pens, paintbrushes or quill pens

Structuring the character

1

Make a preliminary sketch that sets out proportion, then draw in axes and establish a pose. As this character is female, her form should be curved; however, for now just concentrate on correctly distributing the different elements of the drawing on paper.

Character design

2

Add volume and draw in the axes. Don't forget that this character presents a three-quarter view; it is important that different body parts are in perspective. Drawing characters from the front can make them appear flat on the page, while this subtly different perspective results in more realistic, three-dimensional figures.

Placing accessories and details **3**

Place and sketch in accessories and other details, observing the rules of perspective; use your axes to guide you. Now is a good time to develop the character's curves.

Define the rest of the character

Next reinforce her outline, using your sketched version to draw in definitive lines. The important thing is that your sketch is as complete as possible so that you do not have to make changes during the inking process.

4

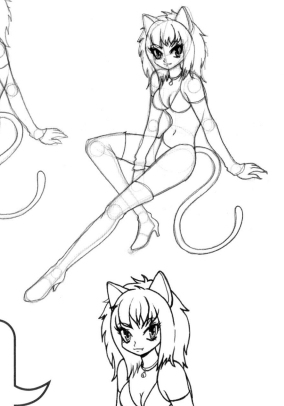

5

Tracing in ink

Fix a fresh sheet of paper over your finished sketch with adhesive tape and position on a light box. Choose the inking technique that you feel most comfortable with; marker pens and stylographs are easiest to use, but for the best result use quill pens or paintbrushes. Work from left to right (or if you are left-handed, from right to left) so that you do not smudge the ink with your hand. It is vital that your lines are bold and confident.

Eyes

Structure

Sketch the shape of the character's eyes. Include their main features: pupils, eyebrows, eyelashes, and so on.

Placing details

Now pay closer attention to details. If you highlight the brightness, contours and symmetry of her eyes, you will maximize their expressiveness. However, try to ensure that her gaze appears to be natural.

Defining and clarifying

Finally, define the different components of the eyes as perfectly as possible. You could also shade the areas that you will later ink in black, giving you a better idea of how your final result will look.

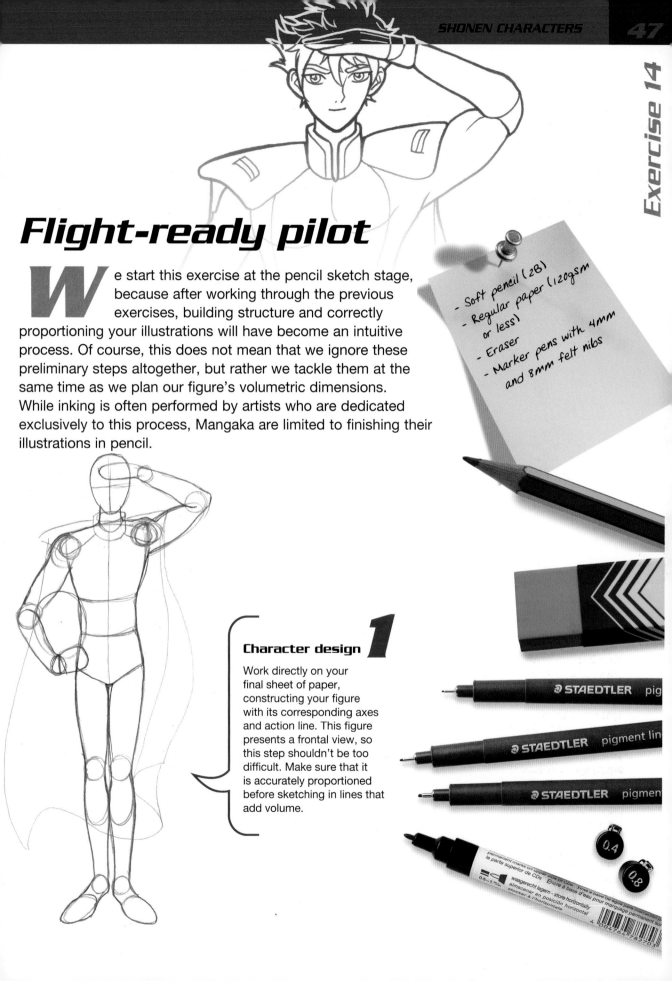

Flight-ready pilot

We start this exercise at the pencil sketch stage, because after working through the previous exercises, building structure and correctly proportioning your illustrations will have become an intuitive process. Of course, this does not mean that we ignore these preliminary steps altogether, but rather we tackle them at the same time as we plan our figure's volumetric dimensions. While inking is often performed by artists who are dedicated exclusively to this process, Mangaka are limited to finishing their illustrations in pencil.

- Soft pencil (2B)
- Regular paper (120gsm or less)
- Eraser
- Marker pens with 4mm and 8mm felt nibs

Character design 1

Work directly on your final sheet of paper, constructing your figure with its corresponding axes and action line. This figure presents a frontal view, so this step shouldn't be too difficult. Make sure that it is accurately proportioned before sketching in lines that add volume.

Add details and accessories

2

Place features over the volumetric structure of your pilot's face and improve the outline of his hands before moving on to his helmet, shoulder pads, belt, cloak, and so on. Try to leave a very approximate outline that will guide you in your definitive outlining process.

Clarify and define the figure

3

Clarify the entire figure and highlight the most important lines, taking great care to create an accurate finish, which will help you later when it is time to begin inking.

Although marker pens are easy to use, the dark colours, especially blacks, tend to fade over time.

4

Tracing in ink

Experiment with every available inking material and technique; they can all be useful depending on your chosen subject. However, you should use felt-tipped marker pens here because they will facilitate the next step in this exercise. Outline the entire figure with your 4mm marker pen, keeping your lines steady and uniform.

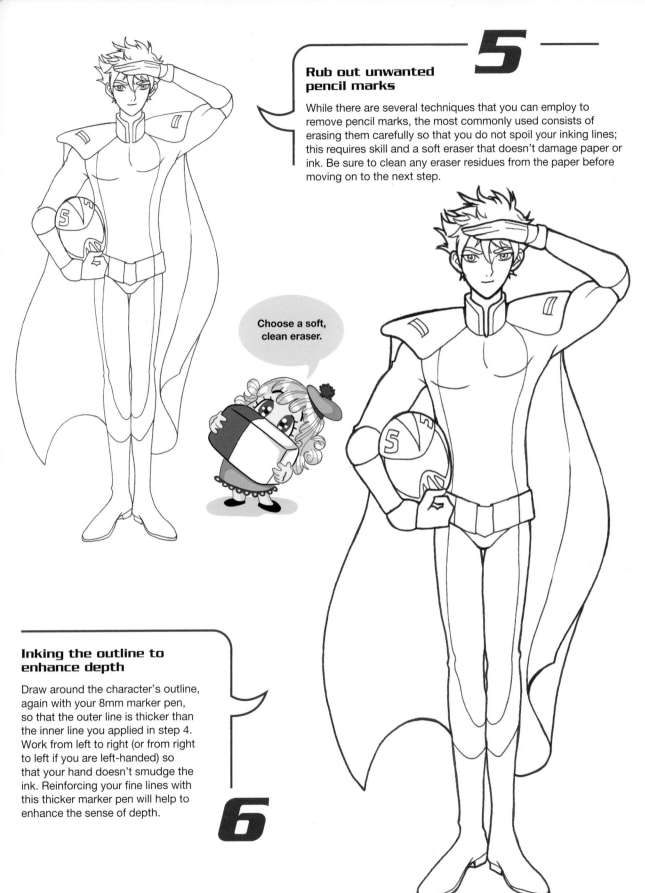

5

Rub out unwanted pencil marks

While there are several techniques that you can employ to remove pencil marks, the most commonly used consists of erasing them carefully so that you do not spoil your inking lines; this requires skill and a soft eraser that doesn't damage paper or ink. Be sure to clean any eraser residues from the paper before moving on to the next step.

Choose a soft, clean eraser.

Inking the outline to enhance depth

Draw around the character's outline, again with your 8mm marker pen, so that the outer line is thicker than the inner line you applied in step 4. Work from left to right (or from right to left if you are left-handed) so that your hand doesn't smudge the ink. Reinforcing your fine lines with this thicker marker pen will help to enhance the sense of depth.

6

Street fighter

- Soft pencil (2B)
- Regular paper (120gsm)
- Eraser
- Marker pens with 4mm and 8mm felt nibs
- Medium round paintbrush
- Indian ink

Here are two new concepts. The first is a subtle ink-tracing technique that combines the application of curved and straight lines. While you have predominantly used curved lines in previous exercises, this character has a 'harder' appearance; its lines are straighter without losing their spontaneity and fluency. The second new concept is an ink-fill technique that we can use to achieve an aesthetic finish typical of Manga comic books.

Character design

Work directly on your final sheet of paper, constructing your figure with its corresponding axes and action line. As an all-action pose is required, take great care to properly balance this character's structure and volume.

1

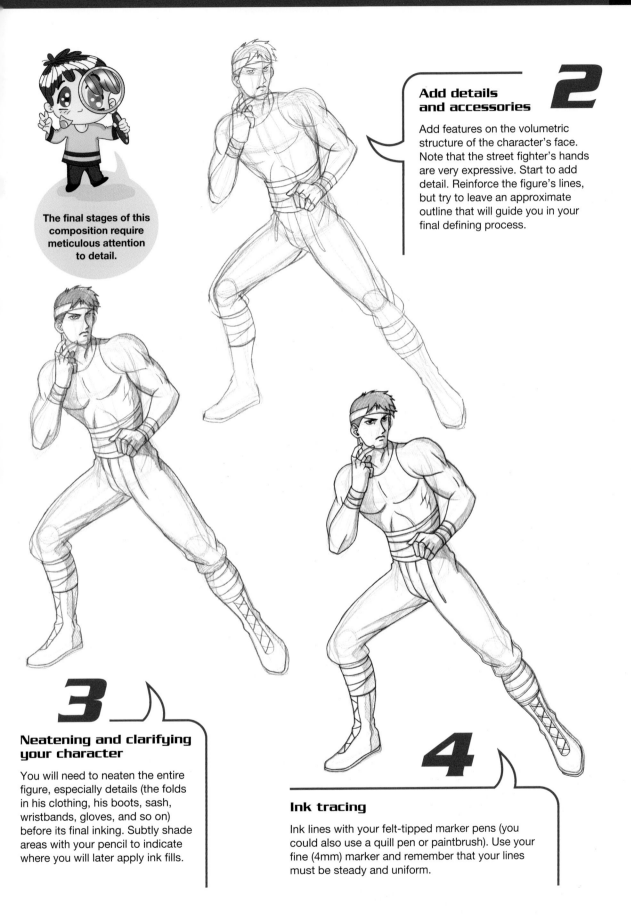

The final stages of this composition require meticulous attention to detail.

2 Add details and accessories

Add features on the volumetric structure of the character's face. Note that the street fighter's hands are very expressive. Start to add detail. Reinforce the figure's lines, but try to leave an approximate outline that will guide you in your final defining process.

3 Neatening and clarifying your character

You will need to neaten the entire figure, especially details (the folds in his clothing, his boots, sash, wristbands, gloves, and so on) before its final inking. Subtly shade areas with your pencil to indicate where you will later apply ink fills.

4 Ink tracing

Ink lines with your felt-tipped marker pens (you could also use a quill pen or paintbrush). Use your fine (4mm) marker and remember that your lines must be steady and uniform.

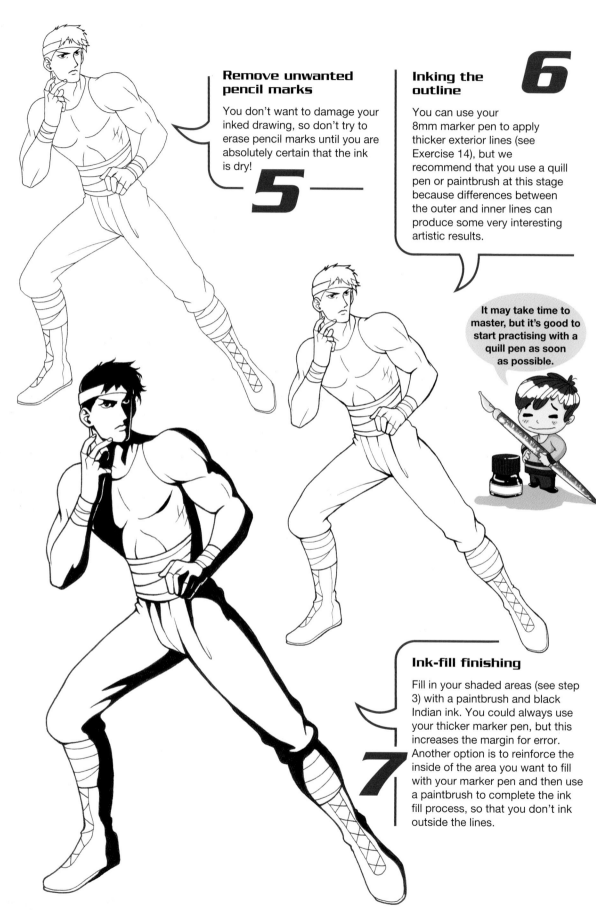

Remove unwanted pencil marks

You don't want to damage your inked drawing, so don't try to erase pencil marks until you are absolutely certain that the ink is dry!

5

Inking the outline

6

You can use your 8mm marker pen to apply thicker exterior lines (see Exercise 14), but we recommend that you use a quill pen or paintbrush at this stage because differences between the outer and inner lines can produce some very interesting artistic results.

It may take time to master, but it's good to start practising with a quill pen as soon as possible.

Ink-fill finishing

Fill in your shaded areas (see step 3) with a paintbrush and black Indian ink. You could always use your thicker marker pen, but this increases the margin for error. Another option is to reinforce the inside of the area you want to fill with your marker pen and then use a paintbrush to complete the ink fill process, so that you don't ink outside the lines.

7

Fearless heroine

This exercise introduces two new advanced techniques: the use of sensual forms and a much higher level of detail in finishing. You will use screentones to create halftone areas, giving this character an appearance worthy of any Manga comic book page. Using screentones is delicate and painstaking work, but the excellent results are worth it. There are many different formats on the market; traditionally a laminated, patterned adhesive film is used, which you position and then trim with a scalpel (taking care not to damage the image underneath). Others are rubbed onto the paper as a transfer. However, the most commonly used screentone (and easiest to apply) is created by computer software. Here you will continue to work with laminated adhesive film (also see Exercise 3), which will get easier the more you practise.

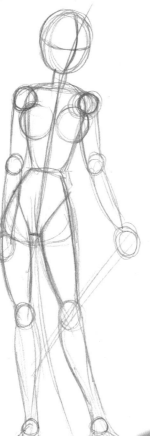

- Soft pencil (2B)
- Regular paper (120gsm)
- Eraser
- Marker pens with 4mm and 8mm felt nibs
- Medium round paintbrush
- Indian ink
- Laminated adhesive screentone

1 Character design

Again work directly on your final sheet of paper, ensuring that your character is correctly designed and proportioned. Remember to focus on volume, proportion and pose at this stage, creating a solid and effective structure rather than representing detail.

Exercise 16

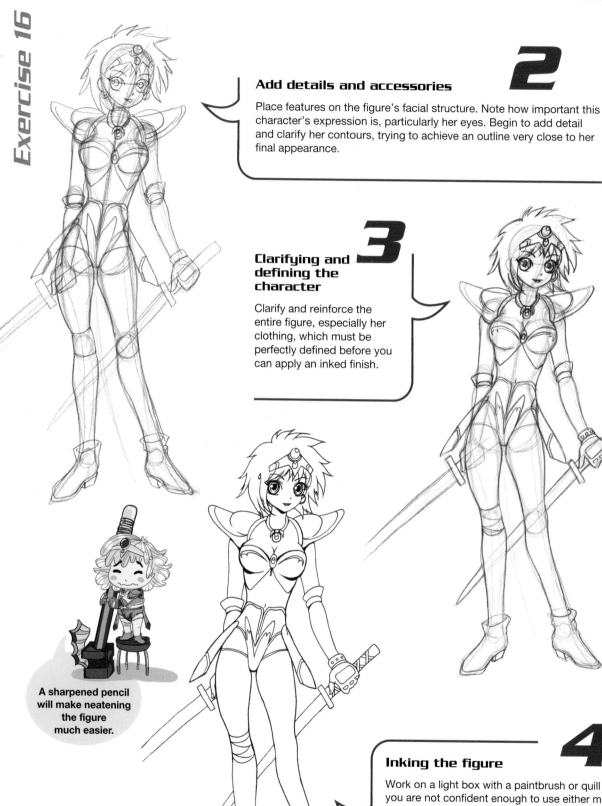

2 Add details and accessories

Place features on the figure's facial structure. Note how important this character's expression is, particularly her eyes. Begin to add detail and clarify her contours, trying to achieve an outline very close to her final appearance.

3 Clarifying and defining the character

Clarify and reinforce the entire figure, especially her clothing, which must be perfectly defined before you can apply an inked finish.

A sharpened pencil will make neatening the figure much easier.

4 Inking the figure

Work on a light box with a paintbrush or quill pen. If you are not confident enough to use either medium, there are marker pens with tips similar to a paintbrush; they are inexpensive, refillable and easier to use than a traditional paintbrush. But at some point, be brave and move away from marker pens, because mastering a paintbrush will give you fantastic results.

Applying adhesive screentones

Before you begin to apply your screentones, you must decide which you are going to use where on your character, how it will be lit and from which direction and what level of dramatic intensity you want. Once you have made up your mind, remove the protective film from a sheet of screentone and place it over the areas that you wish to cover, using the light box to draw shapes in pencil. This technique enables you to create more complex designs.

5

6

Cutting screentones

Using a very sharp scalpel (and taking care not to damage the drawing underneath), cut out the shapes of the different areas that you have decided to fill. After any excess screentone has been trimmed away, you can stick the finished sections to your figure by placing a clean sheet of paper on top of the screentones and applying slight pressure with the palm of your hand. Pick out bright highlights in white gouache.

7

Layering screentones for different effects

While there is a wide range of different screentones available, you can also explore other possibilities. Superimposing another layer of the same type of screentone can result in amazing visual effects and bring more tonal contrast to your work.

Young samurai

The Samurai warrior is the ultimate mythical character, in Japanese legend as well as in Manga. Samurai storylines typically celebrate not only their protagonists' bravery, honour and skill in martial arts, but also the nature of the Samurai code, developed over time through legend and history. In this exercise you will create a colour illustration using marker pens, a simple technique with the capacity to produce amazing results and brilliant finishes. There are many brands on the market and, while the most expensive are not necessarily the best, markers commonly found in the classroom will not allow you to achieve a satisfactory finish. What really matters is that they can be adapted to suit the job in hand.

- Soft pencil (2B)
- Eraser
- Smooth-surfaced (or silk-coated) paper, 120gsm or above
- Inking utensils, preferably a quill pen
- Felt-tipped coloured marker pens or watercolour brush pens

1

Pencil drawing

This exercise skips the step-by-step drawing process, which you can create by following the instructions in previous exercises. Here we begin with a finished pencil drawing of the figure ready for inking.

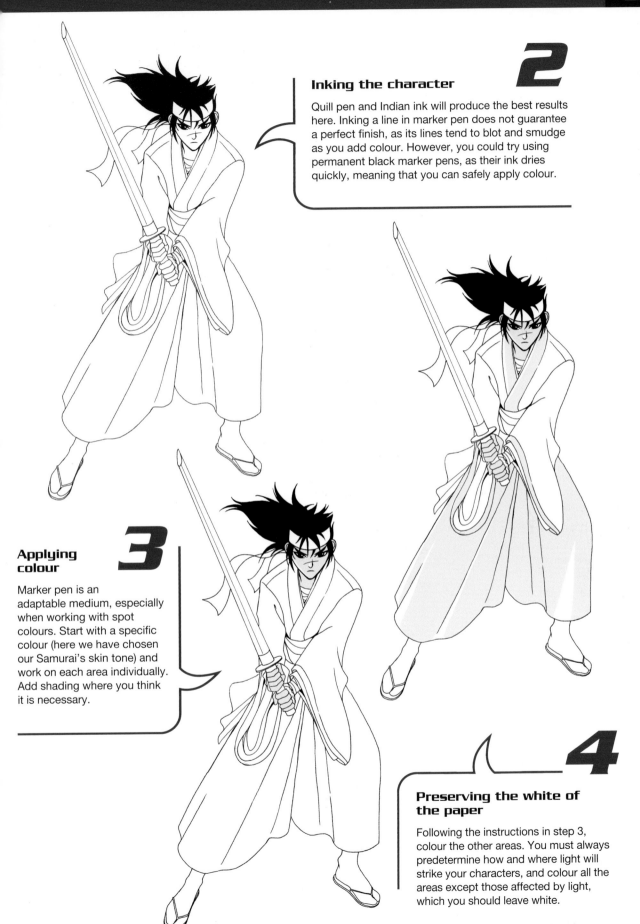

2 Inking the character

Quill pen and Indian ink will produce the best results here. Inking a line in marker pen does not guarantee a perfect finish, as its lines tend to blot and smudge as you add colour. However, you could try using permanent black marker pens, as their ink dries quickly, meaning that you can safely apply colour.

3 Applying colour

Marker pen is an adaptable medium, especially when working with spot colours. Start with a specific colour (here we have chosen our Samurai's skin tone) and work on each area individually. Add shading where you think it is necessary.

4 Preserving the white of the paper

Following the instructions in step 3, colour the other areas. You must always predetermine how and where light will strike your characters, and colour all the areas except those affected by light, which you should leave white.

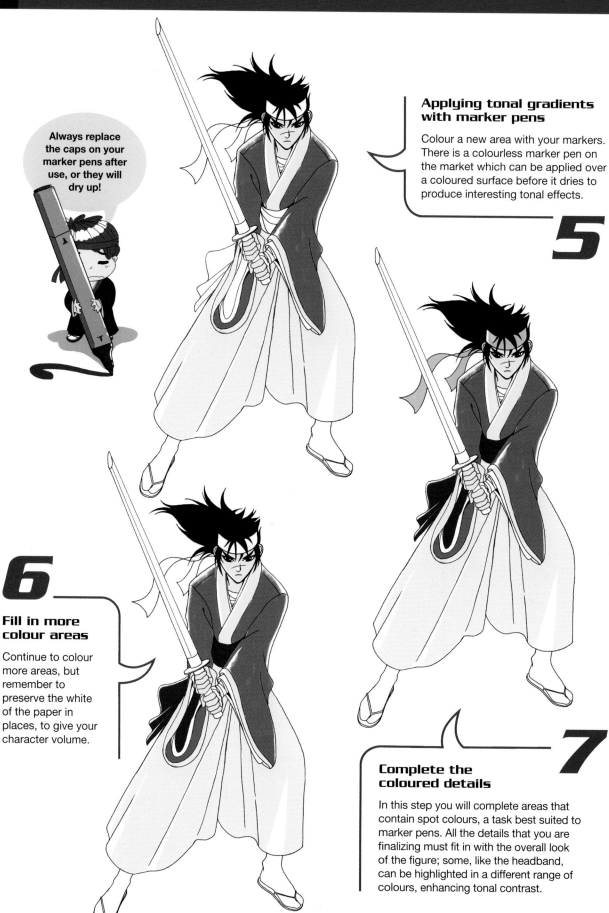

Exercise 17

Always replace the caps on your marker pens after use, or they will dry up!

Applying tonal gradients with marker pens

Colour a new area with your markers. There is a colourless marker pen on the market which can be applied over a coloured surface before it dries to produce interesting tonal effects.

5

Fill in more colour areas

Continue to colour more areas, but remember to preserve the white of the paper in places, to give your character volume.

6

7

Complete the coloured details

In this step you will complete areas that contain spot colours, a task best suited to marker pens. All the details that you are finalizing must fit in with the overall look of the figure; some, like the headband, can be highlighted in a different range of colours, enhancing tonal contrast.

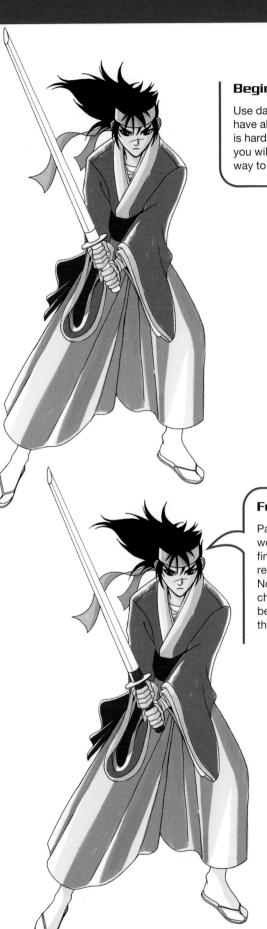

8 Begin shading

Use darker-coloured marker pens to shade the tones you have already applied. Marker pen dries quickly, so there is hardly any risk that your work will be spoiled; in fact you will see how the application of shade is an excellent way to supplement volume.

9 Further details

Pause, check your work thoroughly and finish colouring the remaining details. Note how simply the character's feet have been coloured on this occasion.

10 Final retouching

Finish off your Samurai by filling in the remaining areas of colour (i.e., his sword). You will achieve a more satisfactory finish by enhancing some areas with a new layer of shading, but always make sure that previous layers are completely dry.

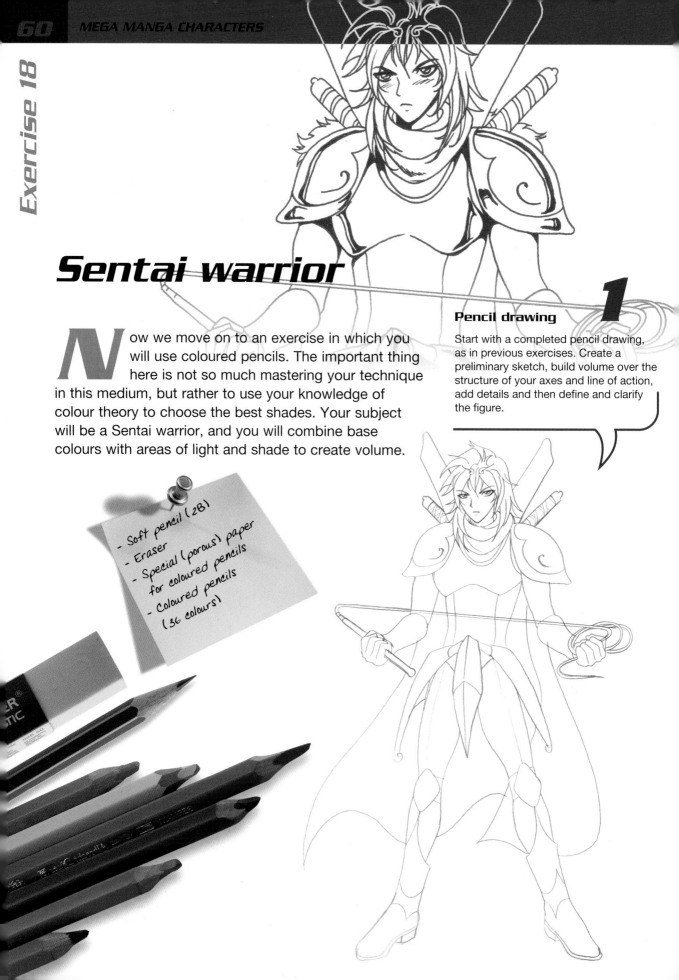

Sentai warrior

Now we move on to an exercise in which you will use coloured pencils. The important thing here is not so much mastering your technique in this medium, but rather to use your knowledge of colour theory to choose the best shades. Your subject will be a Sentai warrior, and you will combine base colours with areas of light and shade to create volume.

Pencil drawing 1

Start with a completed pencil drawing, as in previous exercises. Create a preliminary sketch, build volume over the structure of your axes and line of action, add details and then define and clarify the figure.

- Soft pencil (2B)
- Eraser
- Special (porous) paper for coloured pencils
- Coloured pencils (36 colours)

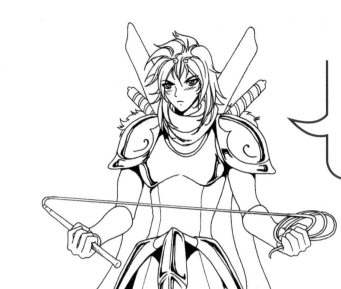

The inking process

It is best to use quill pens and paintbrushes to ink this character; with practice, you will become skilful with these mediums. However, as you will be colouring with pencils, any inking technique will work. Trace your final pencil drawing onto a fresh sheet of porous paper with the help of a light box.

Begin to add colours

One way to apply coloured pencils is to use diagonal strokes in the same direction. The distance between these strokes will determine how intense your colours will be. Always try to keep the same amount of pressure on the pencil while you are colouring.

An alternative technique you can use

Make small spirals or whorls, controlling tonal intensity by exerting uniform pressure on the pencil at all times, or by the number of glazes (very thin layers of colour) that you apply to a specific area. This method will help you to achieve consistent tonal intensity.

Exercise 18

5 Begin by colouring one area

Here you will combine the two techniques outlined in steps 3 and 4. You must take into account the way light falls on the figure, which you must plan before starting to colour. Brighter areas are created by preserving the white of the paper; it is hard to completely erase coloured pencil once you have applied it, and pretty much impossible to return to the pure white of the paper.

6 Refine details and consider lighting

Try to ensure that skin and hair tones are uniform, an important element of Manga characterization. Details and other larger areas should be coloured considering the same working method; that is, to correctly place areas of white paper to create the impression of light.

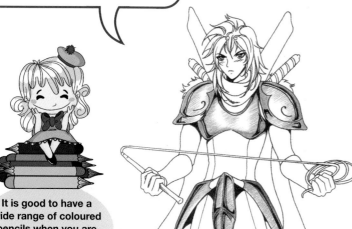

It is good to have a wide range of coloured pencils when you are experimenting with colour mixes.

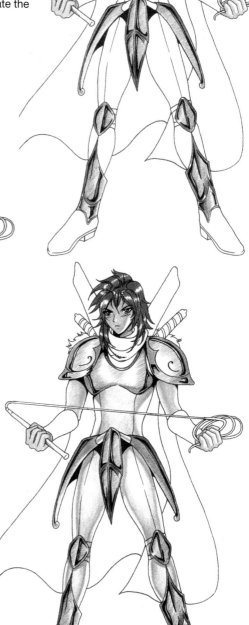

7 Adding volume to your figure

You can add volume by applying successive layers of colour. Observe the newly coloured areas of this character (abdomen, legs and feet). You will see that work began with a very faint layer of colour before a second, more intense layer was applied over only those areas that enhance the volume of the character, making it more three-dimensional.

Darker areas

You can increase the saturation or intensity of a colour by adding further layers. If this saturation is excessive, you won't then be able to add any more layers; but if you overlap a few tones, you can achieve compelling and diverse tonal colours.

8

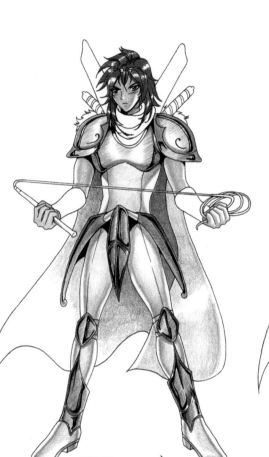

9

How to colour a large area

Colour the centre of a larger area before working your way outwards until the entire area has been covered; in this way you will camouflage its edges. Work so that the brighter sections are more intense in the most visible areas (white reserves) and darker where the figure itself casts a shadow.

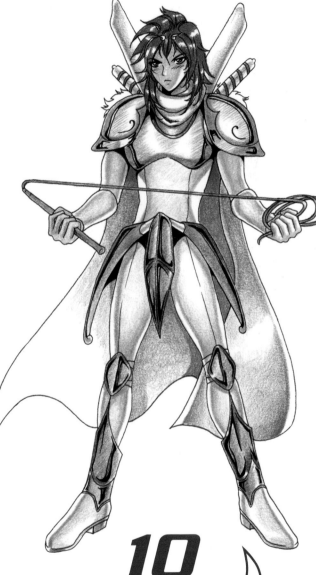

10

Final retouching

Finalize details and add a second layer of colour over the entire character, enhancing its volume. Note that we have used pencils in the same colour range for most of our Sentai warrior, giving him consistency and personal style.

Cyborg

To close this chapter we now bring you an exercise in colouring with digital art software. Any graphics or photographic retouching program will do, as they mainly offer similar colouring tools. You will work on a cyborg character: half man, half machine. This might seem to be a simple task because it presents a limited colour range; there are only a few tones that can be used to create a metallic effect. However, creating this metallic effect is precisely what makes this character more complex than it looks!

- Soft pencil (2B)
- Eraser
- Regular paper (80-120gsm) for first draft
- Inking materials: preferably a quill pen
- Computer with digital art software installed and connected to a scanner

Pencil drawing 1

Sketch and establish your figure around a predetermined structure, then draw details and reinforce the entire character.

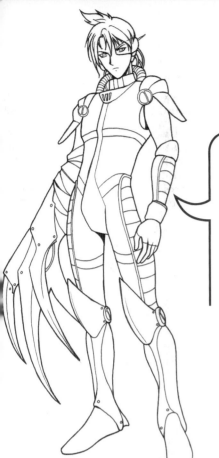

2

Outlining and inking your character

Any of the techniques that we have looked at so far can be used here. The most important thing is that all of the areas are perfectly outlined and enclosed, otherwise colours will permeate other sections.

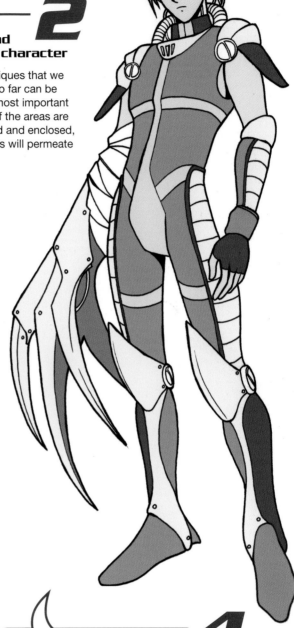

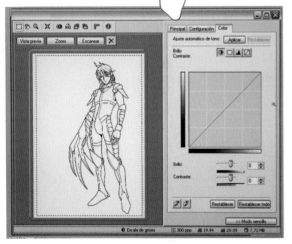

3

Scanning your original pencil drawing

Check that both the glass flatbed of your scanner and your drawing are as clean as possible. Scan the character at 300 dpi resolution and save the image as a tif or jpg.

4

Start colouring

Your first task is to apply spot colours; most programs will allow you to do this easily. Again, it is vital that different areas are properly outlined and enclosed. Next, apply your chosen colours to separate areas with the help of the 'paint fill' tool; a simple mouse click will fill an area with the selected colour.

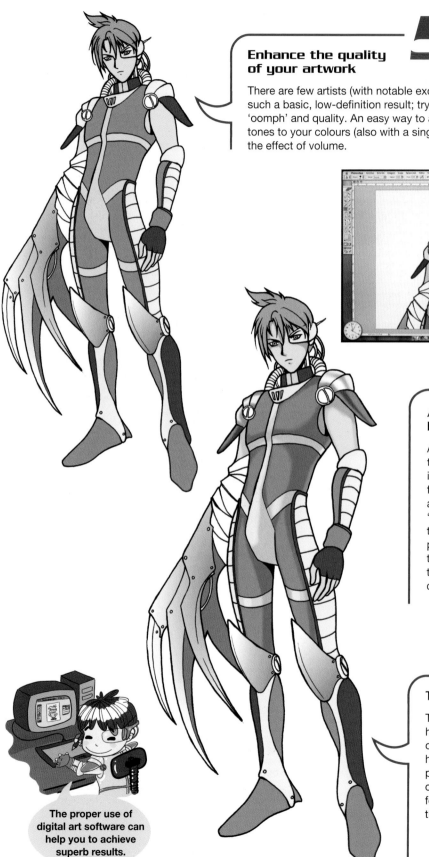

Exercise 19

5

Enhance the quality of your artwork

There are few artists (with notable exceptions) who would settle for such a basic, low-definition result; try to give your art a little more 'oomph' and quality. An easy way to achieve this is to apply graded tones to your colours (also with a single mouse click). This creates the effect of volume.

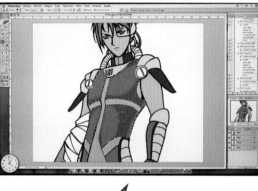

6

Adding white highlights

A technique as simple as reverting to the white of the paper will result in something approaching a well-finished illustration. Just choose the areas you wish to highlight with the 'magic wand' tool. This allows you to superimpose white sections over previously coloured areas; you can then use the 'airbrush' tool to blend these white sections in, achieving a controlled and natural-looking finish.

7

The 'airbrush' tool

This tool allows you to create white highlights or intensify shading by overlapping tones. If you do not have access to the right graphics program, you can download some of the best programs on the market for free (albeit for a limited time, but this will give you time to practise).

The proper use of digital art software can help you to achieve superb results.

Applying further effects

You also have a variety of filters at your disposal that you can use to create different effects which would be laborious and time-consuming to achieve manually. Working digitally allows us to effectively reproduce any manual technique and can even simulate different types of textured paper. It's all about trial and error.

8

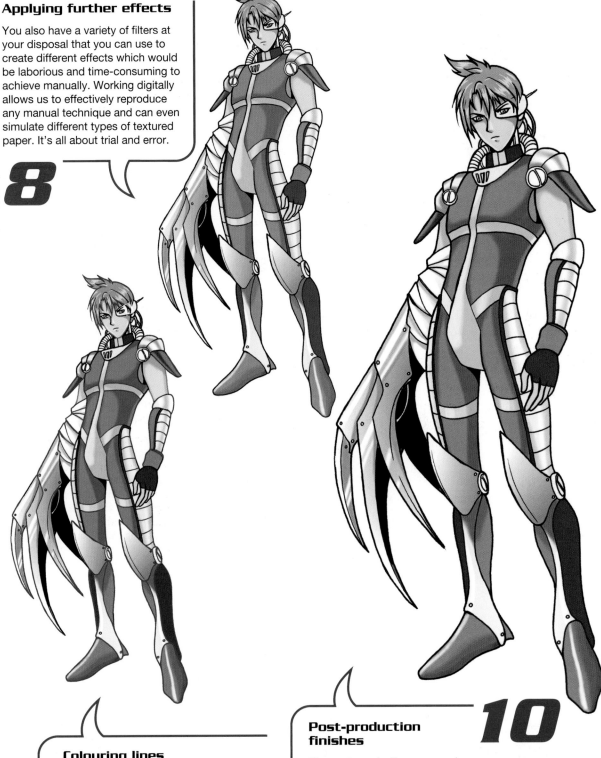

Colouring lines

9

This is another task made simple by a computer. Simply select any line and assign it a new colour layer. The software will automatically colour the selected line, leaving other sections untouched.

Post-production finishes

10

The post-production process is an overall appraisal of your work and the subsequent adjustment of chromatic values such as brightness, contrast and saturation; you can make as many changes as you want to your work until you achieve the required results. A manually coloured illustration can also be scanned and then modified in this way.

SHOUJO CHARACTERS

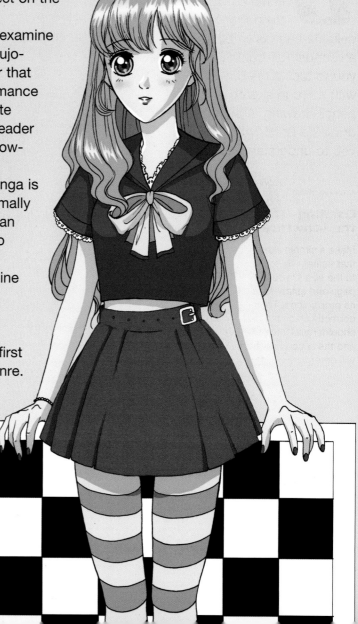

Next we will look at some examples of Shoujo characters, a genre increasingly popular with Western audiences. Shoujo is considered 'Manga for girls' and its romantic themes, melodramatic storylines and underlying sense of humour add interest and intrigue to its dramatic content.

Shoujo characters are represented in a naturalistic style (that is to say, they look real); however, this genre moves away from a purely realistic structure in terms of proportion. We therefore find characters that have been stylized and idealized to have a certain effect on the reader... to make them fall in love.

Throughout this chapter you will examine and learn how to draw classic Shoujo-style characters. Always remember that Shoujo narrative is centered on romance and the emotions; it is vital to create appealing characters to keep the reader involved throughout its relatively slow-paced stories.

A signature feature of Shoujo Manga is its characters' eyes, which are normally large, with huge pupils that reflect an exaggerated amount of light. It also highlights the fragility of some its characters with a very narrow jaw line and a small, sometimes even non-existent nose.

We have prepared the following exercises to help you to take your first confident steps into this Manga genre.

Classic Shoujo handsome youth

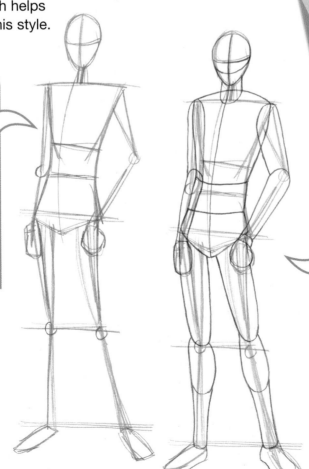

Our first character is essentially an exercise in male physiology. In this case, bear in mind that his features must be fine and delicate and his limbs and neck stylized. He presents an almost full-frontal, static pose, making it easier for you to tackle the drawing successfully. You will start with a rough sketch and end up with a high-quality pencil drawing. A separate section explains how to draw the head, which helps you to understand this style.

- Soft pencil (2B)
- Regular paper (80-120gsm)
- Eraser

1 Creating the structure

Make a simple sketch that scales the figure to the size of your page and establishes its proportions. Try to correctly place the hip, shoulder and knee axes and the action line that will determine his pose.

2 Designing your character

Add the circles and ovals needed for the various chest and abdominal areas and limbs, working over your basic structure. Refine his pose by locating this structure over the action line.

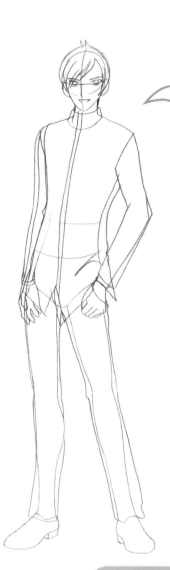

Add anatomical details 3

Once your figure is established and structured, check his proportions before sketching his eyes, nose and mouth. Next outline other anatomical forms: hands, knees, elbows and the shape of his face, before moving on to his clothing.

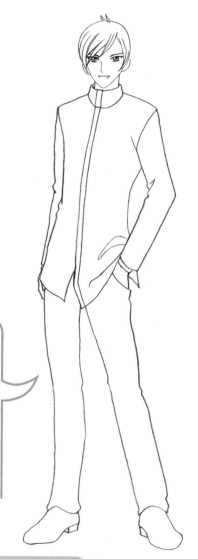

Tracing the completed figure 4

Sharpen your pencil and prepare a clean sheet of paper on which to trace your completed sketch (ideally over a light box). Trace the figure's anatomical details, clothing and general outline. If you do not have access to a light box, you can always trace onto greaseproof paper, but be sure to experiment with pencil strokes first.

The character's head

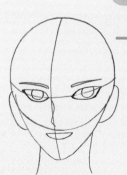

Structure

Draw two lines to indicate cranial and maxillary structures (skull and jaw), placing them over the axis that makes the face symmetrical. Position the eyes, nose, mouth and other features in relation to these. Note that the tops of the ears are aligned with the tops of the eyes and the bottoms are level with the top of the mouth.

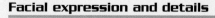

Facial expression and details

Pay close attention to his hair, a characteristic that can be used to help define personality. Develop his facial expression and the shape of his eyes, ensuring that the features are evenly distributed and the face is properly defined.

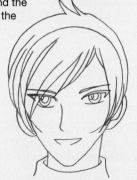

Retouching and defining

Check structure and adjust it with minor retouching as required, before beginning to clarify your sketched elements to give them their definitive form.

Schoolgirl

The schoolgirl is another character typical of Shoujo Manga; normally she shares adventures, experiences and romance with her friends. While this exercise is very similar to Exercise 20, we will give our character a more polished finish; the aim here is to acknowledge the similarities and differences between male and female Shoujo characters. Again, try to idealize her proportions, giving her the personality and expressiveness that we are trying to achieve.

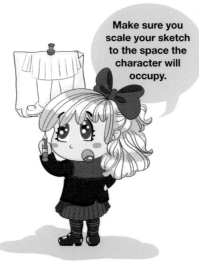

Make sure you scale your sketch to the space the character will occupy.

- Soft pencil (2B)
- Regular paper (80-120gsm)
- Eraser

1

Initial sketch

Now is not the moment to add detail or apply any particular finish – just establish your character's pose, proportions and balance.

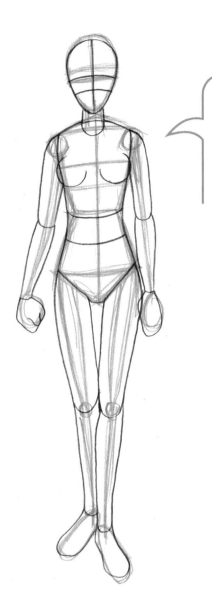

2

Creating volume

Plot circles and ovals to find the right volume for your character. Although she presents an almost face-on pose, try to work a high level of three-dimensionality into your sketch.

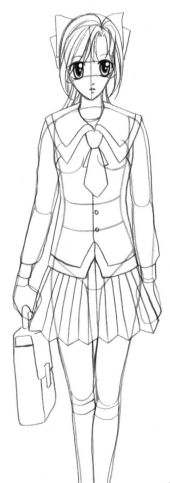

3

Add details

Draw the head and facial expression over your sketched structure, and then add her clothing and other accessories using the same technique. Finishing is unnecessary at this point (because this is still considered part of the sketching process); the important thing is to properly represent details without worrying too much about the quality of your lines.

4

Refining and finalizing the drawing

Review your figure's structure and outline. The sketch will no doubt contain duplicate or multiple sketchy strokes and lines; delete these and use your pencil to reinforce lines that you will use for your final version, while simultaneously refining details that you sketched in step 3.

Pop idol

O ur character here is a young singer and your aim is to achieve a polished and professional finish. We have mentioned the importance of access to a light box before; it will help you to eliminate superfluous lines from your rough sketch and evaluate a character's finished outline. Drawing this singer is a complicated process because she presents a three-quarter view and is striking a dynamic pose. You will learn to make your pencil strokes stronger and improve your inking technique.

- Soft pencil (2B)
- Regular paper (80–120gsm)
- Tracing paper (120gsm or less)
- Eraser
- Light box

1 Create the structure

This important first step involves the layout of axes on which to establish your singer's proportions and the action line which denotes the dynamics of her pose.

2 Volume and proportion

Work with care when establishing volume and proportion, as this character's body presents a three-quarter view and the perspective must be very accurate. Add in the usual circles and ovals, taking special care when sketching over the axes that define perspective and the movement dynamic.

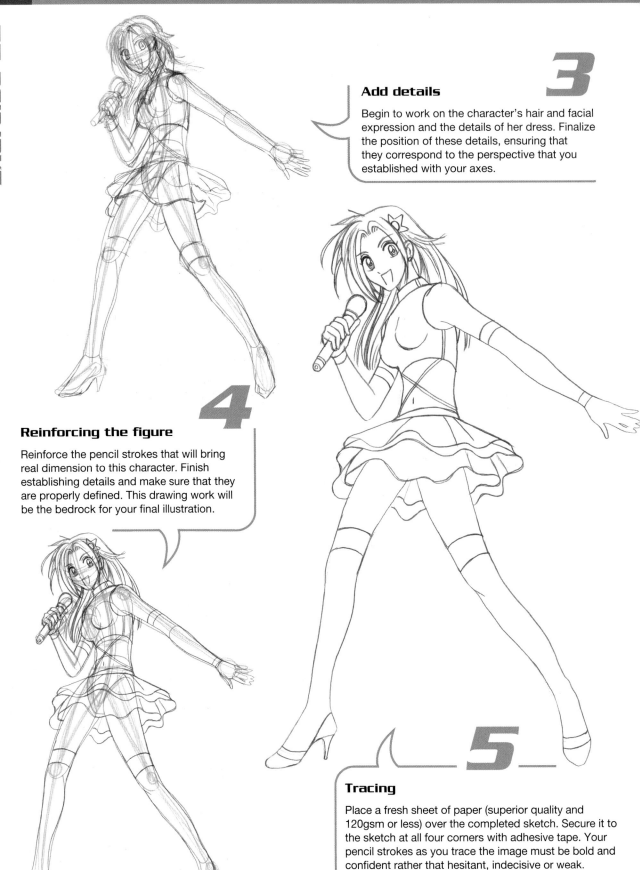

Exercise 22

3
Add details

Begin to work on the character's hair and facial expression and the details of her dress. Finalize the position of these details, ensuring that they correspond to the perspective that you established with your axes.

4
Reinforcing the figure

Reinforce the pencil strokes that will bring real dimension to this character. Finish establishing details and make sure that they are properly defined. This drawing work will be the bedrock for your final illustration.

5
Tracing

Place a fresh sheet of paper (superior quality and 120gsm or less) over the completed sketch. Secure it to the sketch at all four corners with adhesive tape. Your pencil strokes as you trace the image must be bold and confident rather that hesitant, indecisive or weak.

Teenage girl with pet

Here you will work on a simple composition in which two characters appear in the same scene: a teenage girl and her pet, common in both Shoujo and Shonen Manga. In addition to structure, volume, pose and proportion, sensual curves and highly detailed eyes are very important. To further your technique, you will apply a simple ink finish (without shading or semitones); the aim here is to produce a finish that is as assured and accomplished as if it was drawn in soft pencil.

1 Structuring the characters

Structure your characters following the procedure laid out in previous exercises, but this time remember to include 'cute' features and rounded, sensual shapes. Make a sketch that sets out the position of the two characters on your paper, so that they are in proportion and integrated together.

- Soft pencil (2B)
- Regular paper (80-120gsm)
- Tracing paper (120gsm or less)
- Eraser
- Inking utensils: marker pens, stylograph pens, paintbrushes or quill pens (whichever medium you are more comfortable with)

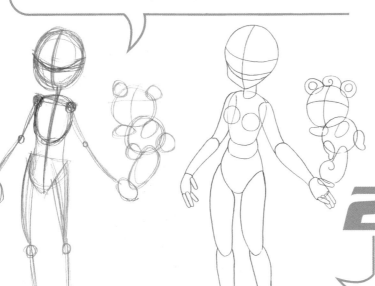

2 Creating volume

Supplement your basic structure by sketching ovals and circles over your axes. Drawing characters from the front can make them appear flat on the page, while this subtly different perspective results in more realistic three-dimensional figures.

Place details and accessories

3

Sketch on details, placing them in perspective as dictated by your axes, then improve the definition of the anatomical characteristics. This is a good time to practise working on curved and sensual shapes.

Establishing and defining the character

4

Next reinforce the character's outline, building on your sketched version with more definitive lines. Your sketch should be finished so that your inking process can be as decisive as possible; by this point you should be confident in how you establish your figures and place their components.

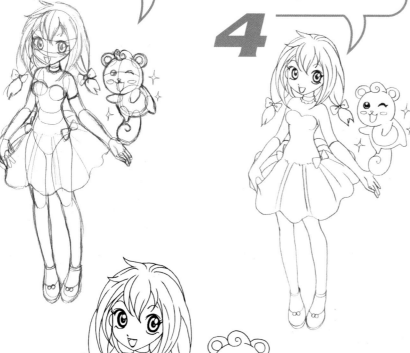

Ink tracing

5

Place your finished sketch on a light box and fix a fresh sheet of paper on top using adhesive tape. Choose the inking technique that you feel most comfortable with; marker pens are easy to use, but for the best result, use quill pens or paintbrushes. Work methodically from left to right (or if you are left-handed, from right to left) so that you do not smudge the ink with your hand. It is vital that your lines are bold and confident.

Eyes

Structure

Sketch out the shape and structure of the eyes, suggesting their most important details: pupils, eyebrows, eyelashes, and so on.

Placing details

Now pay closer attention to details. If you highlight the brightness, contours and symmetry of the eyes, you will maximize their expressiveness. However, try to ensure that her gaze appears to be natural.

Defining and shading the eyes

Finally, define the eyes' details as perfectly as possible. You could also shade areas that you will later ink in black, giving you a better idea of what your final result will look like.

Wicked witch

Here we assume that you have created a rough-draft sketch because you are already proficient in both using the pencil and establishing your characters. While you should follow the initial steps from previous exercises, try to plan the general volume of this figure at the same time.

Work at refining your pencil stroke by repeating it (make sure that the lead of your soft pencil is well sharpened); a confident pencil stroke will yield a very professional result. Artists don't develop the ideal pencil stroke overnight: professionals spend long hours in front of their drawing boards, so keep practising! Your time and effort will pay off when it comes to inking your characters.

- Soft pencil (2B)
- Tracing paper (120gsm or less)
- Eraser
- Inking utensils: marker pens with 4mm and 8mm felt nibs

Character design **1**

Sketch the figure's action line and axes directly onto your final piece of paper. This character is posed in a slight three-quarter view, so pay close attention to perspective. The most important considerations at this stage are her pose, proportions, axes and volume.

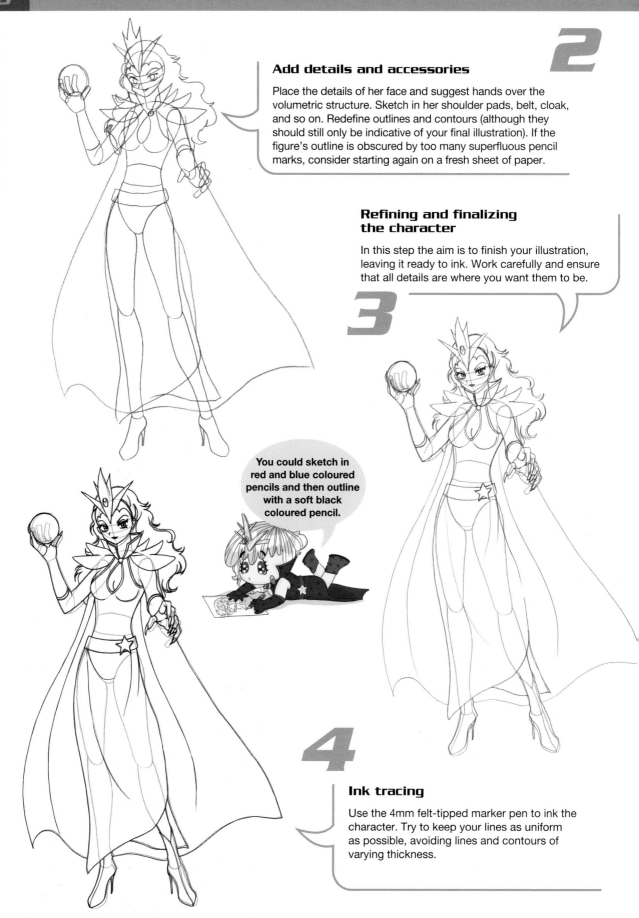

Exercise 24

2

Add details and accessories

Place the details of her face and suggest hands over the volumetric structure. Sketch in her shoulder pads, belt, cloak, and so on. Redefine outlines and contours (although they should still only be indicative of your final illustration). If the figure's outline is obscured by too many superfluous pencil marks, consider starting again on a fresh sheet of paper.

Refining and finalizing the character

In this step the aim is to finish your illustration, leaving it ready to ink. Work carefully and ensure that all details are where you want them to be.

3

You could sketch in red and blue coloured pencils and then outline with a soft black coloured pencil.

4

Ink tracing

Use the 4mm felt-tipped marker pen to ink the character. Try to keep your lines as uniform as possible, avoiding lines and contours of varying thickness.

Exercise 24

Erase pencil marks

5

Select a soft eraser that will not damage your paper or ink drawing and gently erase your pencil marks.

It's a good idea to combine the delicacy of a 4mm marker pen with the stronger 8mm one as you ink.

Creating depth and definition by inking lines

6

Go over the outer lines of your figure again with your 8mm marker pen, to make them thicker than the rest. Work from left to right (or if you are left-handed, from right to left) so that you do not smudge the ink with your hand. Inking in this way means that the viewer can easily distinguish the figure from any background when it is inserted into a vignette.

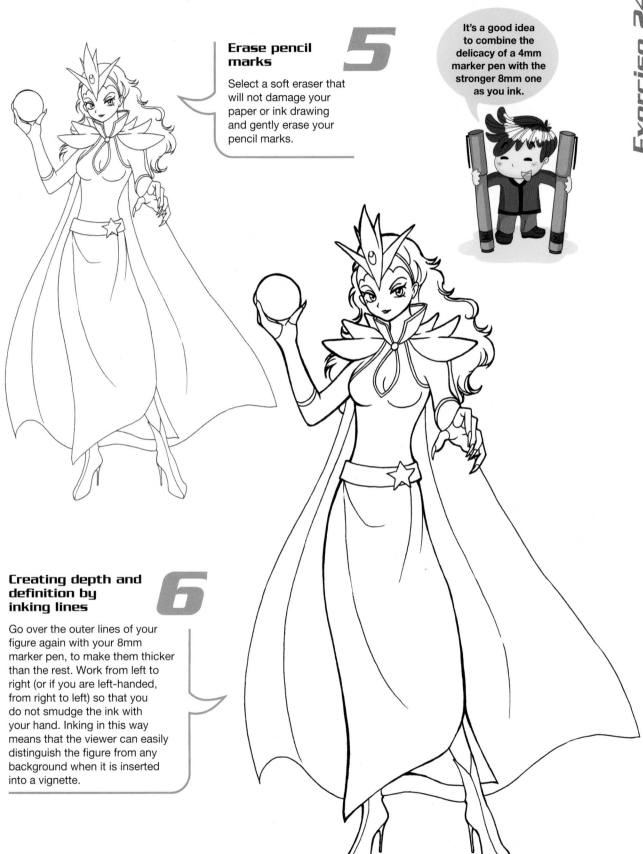

Masked prince

The next exercise is a study in colouring using marker pens. High-quality markers do cost a little more, but those typically found in your school classroom will certainly not be up to the job. Our character here is a masked prince typical of Shoujo Manga. He is often found at the centre of romantic plot lines as an important foil to the female protagonist.

- Soft pencil (2B)
- Regular paper (80-120gsm) for sketching
- Smooth-surfaced (or silk-coated) paper, 120gsm or above
- Eraser
- Colouring tools: A wide range of felt-tipped or brush-tipped marker pens

Learning to sketch fluently takes hours of practice.

R37
Carmine

1 Character design

As you have already learned how to create a first-draft sketch, we now move on to creating volume in the figure. Use the same piece of paper that you used to sketch on for this step; professional Mangakas generally work on both steps simultaneously.

2
Start to add detail

Roughly sketch accessories and other details: his cloak, hair, mask, and so on. Your aim is to correctly position these details, which you will later carefully enhance.

3
Refining the character

After establishing and outlining the figure, take time to develop the expressiveness of his face and hands, then his clothing and accessories. Work with care you and you will achieve an excellent finish.

4
Ink tracing

If you are still not confident enough to go over the lines with a quill pen or paintbrush, you can continue to ink with a marker pen; be sure to use permanent ink so that subsequent layers of colour do not mix together.

Exercise 25

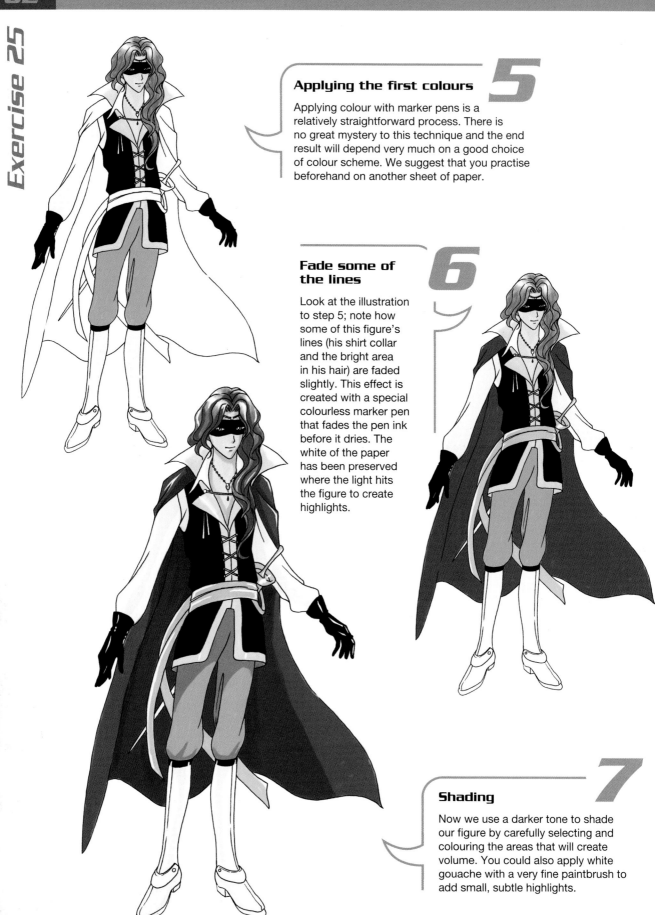

Applying the first colours

5

Applying colour with marker pens is a relatively straightforward process. There is no great mystery to this technique and the end result will depend very much on a good choice of colour scheme. We suggest that you practise beforehand on another sheet of paper.

Fade some of the lines

6

Look at the illustration to step 5; note how some of this figure's lines (his shirt collar and the bright area in his hair) are faded slightly. This effect is created with a special colourless marker pen that fades the pen ink before it dries. The white of the paper has been preserved where the light hits the figure to create highlights.

Shading

7

Now we use a darker tone to shade our figure by carefully selecting and colouring the areas that will create volume. You could also apply white gouache with a very fine paintbrush to add small, subtle highlights.

Ghost

By this point, we assume that you have been brave enough to at least experiment with a paintbrush – if not, you have now run out of excuses! The use of a paintbrush is fundamental to this exercise, where you will create a character with semi-tones using the wash technique. Keep your working area tidy, with a cloth for cleaning your paintbrush and scrap paper to hand on which to test your colours. The character we have chosen is a Shoujo Manga staple: a gothic ghost whose ethereal structure makes it ideal for practising this technique.

- Soft pencil (2B)
- Eraser
- Regular paper for first-draft sketch
- Watercolour paper (about 240gsm)
- Inking utensils: preferably a quill pen
- Materials to apply a wash: medium round, fine-tipped paintbrush, Indian ink, white gouache (for retouching), paper adhesive tape and a rigid wooden board on which to stretch your paper (see page 8), cotton cloth

1

The pencil drawing

Follow the step-by-step sketching process detailed in previous exercises to create a finished pencil sketch, ensuring that it is defined, outlined and ready to be inked.

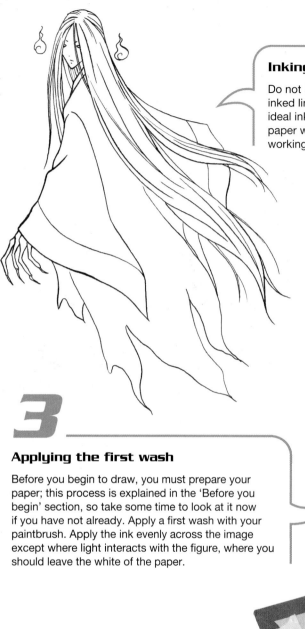

2
Inking the character

Do not ink with marker pen! Diluted colours will spread inked lines across the paper and ruin your drawing. The ideal inking tools are a quill pen if you have chosen a paper with a smooth surface, or a paintbrush if you are working with rough-textured paper.

3
Applying the first wash

Before you begin to draw, you must prepare your paper; this process is explained in the 'Before you begin' section, so take some time to look at it now if you have not already. Apply a first wash with your paintbrush. Apply the ink evenly across the image except where light interacts with the figure, where you should leave the white of the paper.

4
Wash, dry, wash, dry...

Wait until the first layer is dry before applying a second. To reduce drying time between washes, you can use a hairdryer on its lowest heat setting and at a safe distance from the paper.

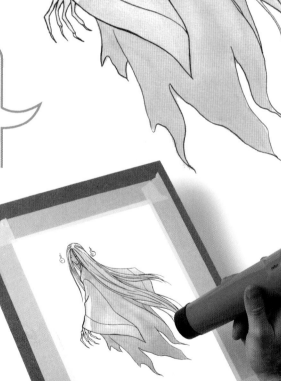

Exercise 26

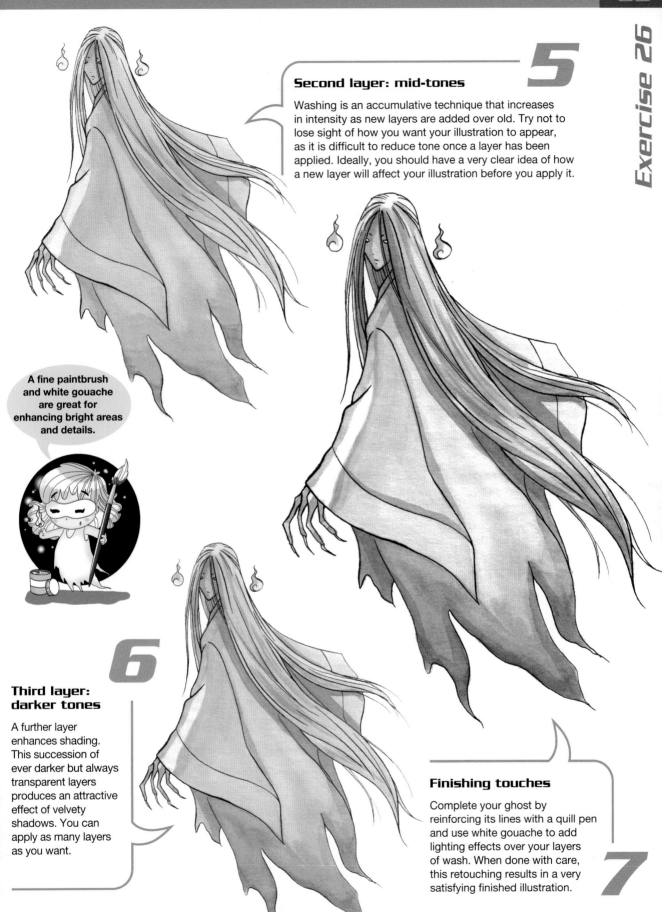

5

Second layer: mid-tones

Washing is an accumulative technique that increases in intensity as new layers are added over old. Try not to lose sight of how you want your illustration to appear, as it is difficult to reduce tone once a layer has been applied. Ideally, you should have a very clear idea of how a new layer will affect your illustration before you apply it.

A fine paintbrush and white gouache are great for enhancing bright areas and details.

6

Third layer: darker tones

A further layer enhances shading. This succession of ever darker but always transparent layers produces an attractive effect of velvety shadows. You can apply as many layers as you want.

Finishing touches

Complete your ghost by reinforcing its lines with a quill pen and use white gouache to add lighting effects over your layers of wash. When done with care, this retouching results in a very satisfying finished illustration.

7

Oriental princess

- Soft pencil (2B)
- Eraser
- Special (porous) paper for coloured pencils
- Coloured pencils (36 colours)

You will use coloured pencils to complete this exercise; the aim is to create a soft-toned, elegant image. While an accomplished colouring technique is important here, it takes second place to a good sense of colour and artistic effect. This character is a young oriental princess and you will work by applying different colours at each stage before creating contrast by making some areas more intense. This method of applying colour is simple but delivers high-end results.

1
The initial pencil sketch

Create your pencil sketch as in previous exercises. Sketch the axes and action line, indicate a volumetric structure, add detail and clarify the drawing.

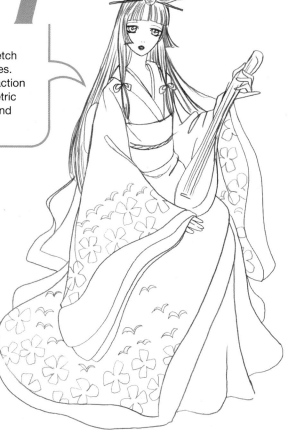

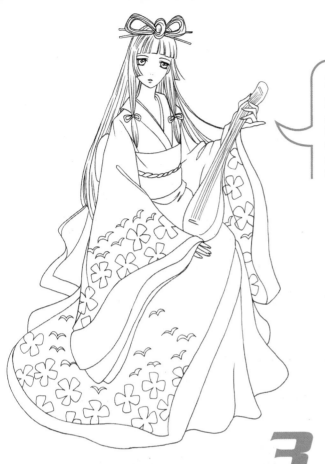

2

Inking the drawing

It is essential to trace your final version onto a fresh sheet of porous paper with the help of a light box. Some artists prefer to ink once they have coloured their illustrations; it is a question of trial and error until you discover which procedure suits you and delivers the most satisfactory results.

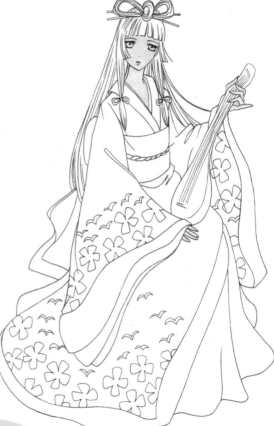

3

Applying coloured pencil

One way to apply coloured pencils is to use diagonal strokes in the same direction. The distance that you leave between these strokes will determine how intense your colours will be. Try to keep the same amount of pressure on the pencil while you are colouring. You can also use small spirals or whorls, controlling tonal intensity by keeping the pressure even, or by the number of glazes (very thin layers of colour) that you apply to a specific area. In this exercise we will use this second technique, but do learn both.

You can apply colour glazes with watercolour pencils as well as ordinary coloured pencils.

4

Applying a base skin tone

Colour your figure's hands and face with small whorls. The porous nature of the paper means that this base skin tone can be applied even with minimal pressure on the tips of your pencils.

5 Add blues

Add blue tones to the character. Subtly colour her hair, preserving the white of the paper to represent highlights. Blend the colours of her sleeves and the bottom of her kimono inwards by gradually decreasing your pressure on the pencils. Her bodice is the darkest toned area, so use a darker blue pencil.

6 Add another layer of colour

Apply a new green base layer, exerting less pressure on your pencil to reduce its intensity and produce a fading effect. While we suggest that you stick to the whorl technique throughout this exercise, there is no reason why you cannot use both the techniques detailed in step 3 of this project.

7 Creating contrast

You can create contrast by intensifying shaded areas. In this step you will contrast the whites with the semitones and darker tones, bringing more relief to the figure.

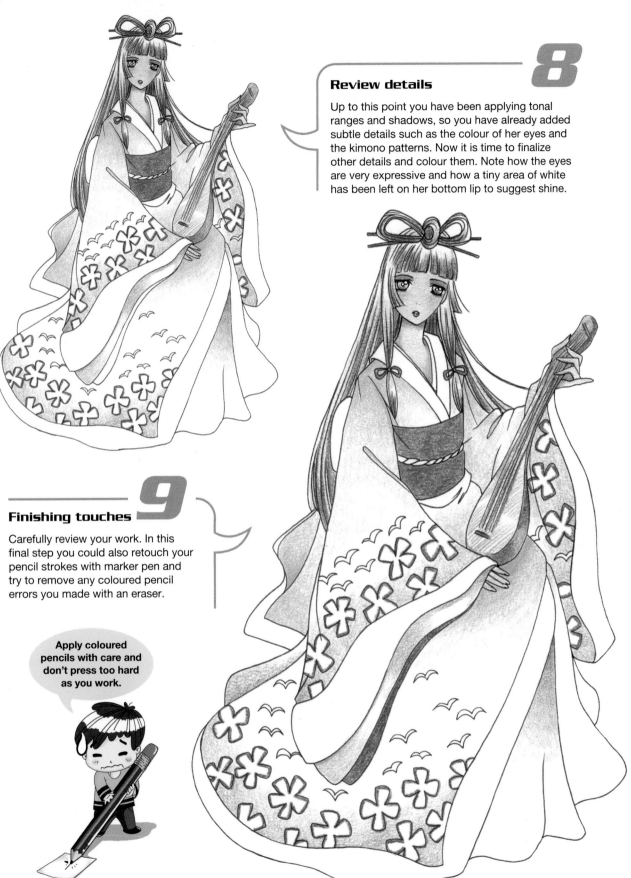

8 Review details

Up to this point you have been applying tonal ranges and shadows, so you have already added subtle details such as the colour of her eyes and the kimono patterns. Now it is time to finalize other details and colour them. Note how the eyes are very expressive and how a tiny area of white has been left on her bottom lip to suggest shine.

9 Finishing touches

Carefully review your work. In this final step you could also retouch your pencil strokes with marker pen and try to remove any coloured pencil errors you made with an eraser.

Apply coloured pencils with care and don't press too hard as you work.

Exercise 28

Magical girl

One of the most endearing Manga characters, this girl's supernatural powers make her an ideal protagonist for many Shoujo storylines. You will use watercolours for this exercise. Although the majority of Manga is black and white, colour is often used in cover artwork and promotional material such as posters and flyers. A Mangaka must therefore be as proficient in colouring techniques as in pencil illustration. This exercise is simple enough but requires patience and accuracy.

- Soft pencil (2B)
- Eraser
- Regular paper for sketching
- Watercolour paper (240gsm)
- Quill pen
- Medium round paintbrush
- Watercolours (standard range)
- White gouache for retouching
- Paper adhesive tape
- Rigid wooden board on which to stretch your paper
- Cotton cloth

Pencil drawing

1

Begin by creating a volumetric structure before adding details and defining and outlining your figure. Try to use bold, uniform and confident pencil strokes.

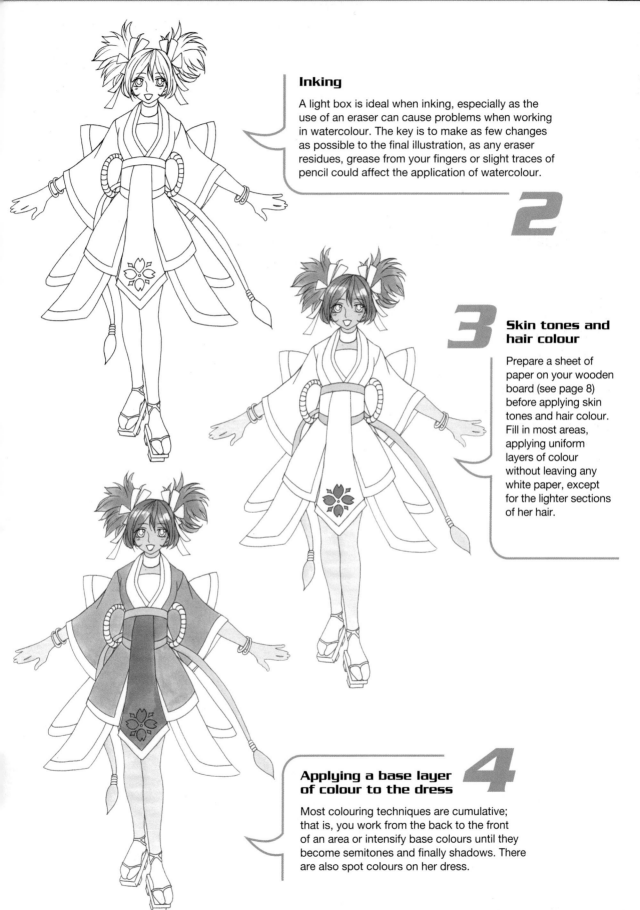

Inking

A light box is ideal when inking, especially as the use of an eraser can cause problems when working in watercolour. The key is to make as few changes as possible to the final illustration, as any eraser residues, grease from your fingers or slight traces of pencil could affect the application of watercolour.

2

3

Skin tones and hair colour

Prepare a sheet of paper on your wooden board (see page 8) before applying skin tones and hair colour. Fill in most areas, applying uniform layers of colour without leaving any white paper, except for the lighter sections of her hair.

Applying a base layer of colour to the dress

4

Most colouring techniques are cumulative; that is, you work from the back to the front of an area or intensify base colours until they become semitones and finally shadows. There are also spot colours on her dress.

Begin to paint details

Follow the same procedure here, applying watercolour spot colours to whole areas apart from her hair and her choker (which both have preserved white paper highlights).

5

Work on the colours

Intensify tones in various areas of your character that are similarly coloured; take care not to mix colours, cleaning your paintbrush on a cotton cloth after each application. This will help to keep your colours vivid and clean.

6

Work on a slightly inclined surface when painting in watercolour.

7

Add shade

Simply reuse the same colours, applying a second layer to the area you wish to shade, always making sure that previous layers are completely dry so that the colours do not run into each other.

8

Intensify shading

You can add new layers as you see fit. A new layer over previously shaded areas subtly enhances this figure's contrast.

9

Intensify the colours

Watercolour doesn't create opaque layers; in other words, if you apply one layer over another, the first layer is visible underneath. If you want to intensify your figure's colours, you must work with darker tones in the same colour range. Here the colours of her dress have been intensified with a darker blue, adding to the sense of volume.

10

Finishing touches: white highlights

While we have simplified this exercise by using mainly spot colours throughout, white highlights are also an important part of its professional-looking finish. Use a very fine, round-tipped brush to pick out highlights in white gouache.

Gothic Lolita

Using a computer with digital photograph retouching software is a popular and contemporary way to draw and colour. There are many different programs available offering similar tools, so in theory you will able to use any of them. During this exercise you will work on a classic Shoujo-style character that calls for good attention to detail, building on the structural and compositional lessons learned so far. You will also be working with a limited range of colours that are best suited to the subject in question.

- Soft pencil (2B)
- Eraser
- Regular paper for first-draft sketch
- Quill pen
- Computer with digital art software installed and connected to a scanner
- Digital graphics tablet (highly recommended)

1

Pencil drawing

As always, work on establishing your figure over its structure, draw details and outline it. Take great care over the detail, as it will emphasize this character's expressiveness.

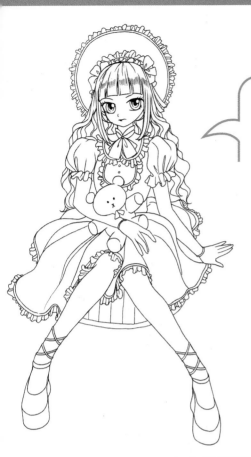

Inking

2

You can apply any of the inking techniques that we have studied so far, but do not forget how important it is that all the areas you are going to fill with colour are perfectly outlined so that the colours do not permeate other areas of your illustration.

Scanning your original pencil drawing

3

Scan the character at 300 dpi resolution and save the image as a tif or jpg. Clean up smudges and small unwanted marks onscreen with the 'eraser' tool.

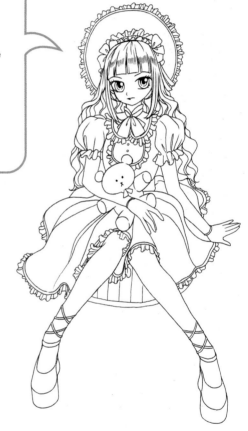

Background and skin-tone base colour

4

Use the 'paint fill' tool to apply a background colour base. Choose another colour to create a background for your skin tone; this should be a very pale tone, just sufficient to break up the white of the paper.

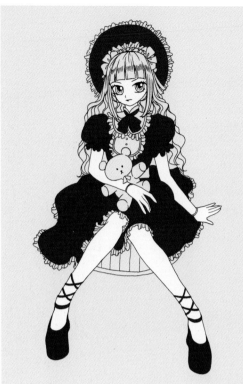

5 Applying a base colour for the clothes

Choose a dark red and colour the dress, again using the 'paint fill' tool. Remember that as you are working digitally, you can quickly correct errors. In any graphics software you will find tools that allow you to manipulate colour parameters, but it is advisable to have a clear idea of what your final image should look like before starting to work.

Digital techniques are efficient, but should not replace classic Manga art techniques.

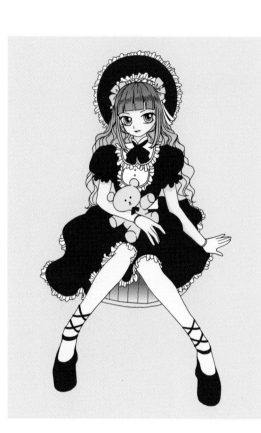

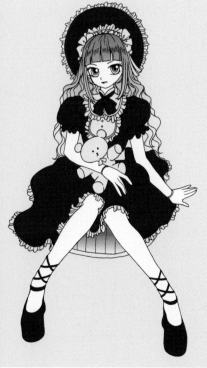

6 Blending tones

Select different areas of your character and add new colours and effects by applying the 'magic wand' tool. Here we have blended her hair colours.

7 Applying lighter tones

Use the 'paint fill' tool again to add lighter tones to the frills and trim of the character's dress and hat, before beginning to shade her skin. This will help her to stand out against the background.

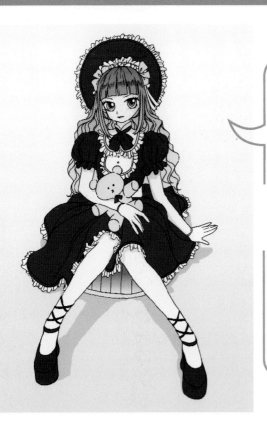

8

Shading

Selecting the background with the 'magic wand' tool allows you to paint over it without having to worry about spoiling your picture. The magic wand creates a barrier that prevents colour from spilling outside a preselected area. You can use the 'airbrush' tool to shade her dress and legs (putting the character in relief) or even create a graded effect in the background colour.

10

Finishing touches

Adjust the intensity of the outline as explained in step 9 and alter parameters until the lines are of the desired quality. The most important task at this final stage is to add subtle details that will enhance the image: highlights, well-defined contours in the folds of her dress, light reflecting off her hat and shoes and so on… all vital to achieve the professional-quality finish we are looking for.

Colouring lines

This character's style and colour scheme call for a more subtle colour effect where its lines need to look less hard. Select a black line and replace it with a brown one.

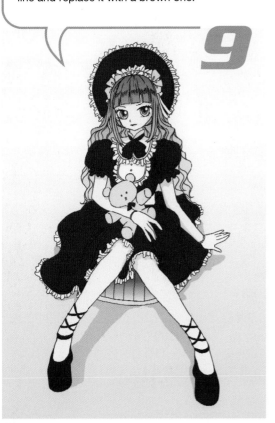

9

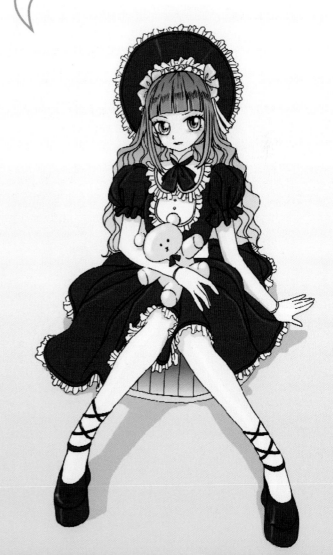

SEINEN CHARACTERS

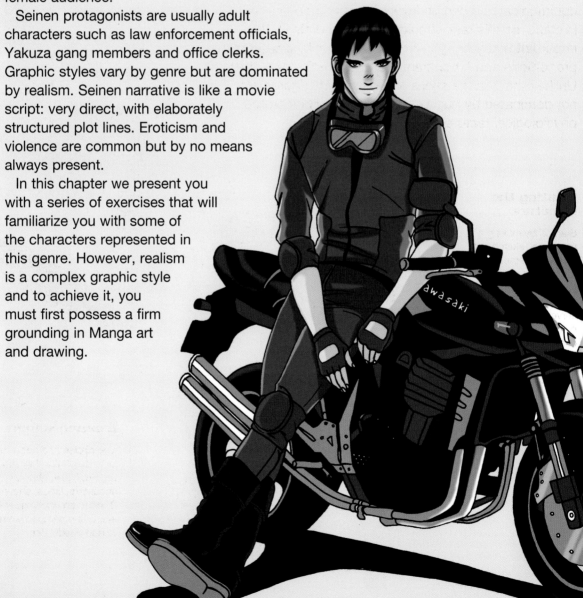

Seinen is one of the Manga genres most similar to Western comic books in terms of its narrative and aesthetics. Seinen translates as 'age of majority' and is targeted at a male audience aged 18 years or over. Its feminine equivalent is called Josei or LadyComi: Manga aimed at a twenty-something female audience.

Seinen protagonists are usually adult characters such as law enforcement officials, Yakuza gang members and office clerks. Graphic styles vary by genre but are dominated by realism. Seinen narrative is like a movie script: very direct, with elaborately structured plot lines. Eroticism and violence are common but by no means always present.

In this chapter we present you with a series of exercises that will familiarize you with some of the characters represented in this genre. However, realism is a complex graphic style and to achieve it, you must first possess a firm grounding in Manga art and drawing.

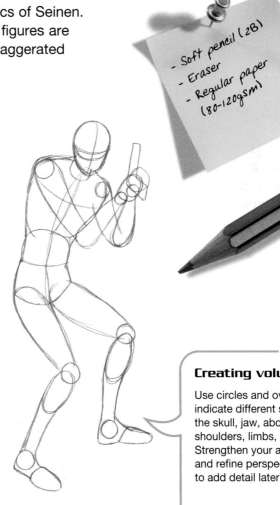

Watchful Yakuza

In your first exercise, you will draw a Japanese Yakuza, an organized crime gang member typical of many Seinen Manga comics. His pose communicates a certain level of tension and yet he is static, so this task should not be too difficult. It is important that you try to adapt to the realistic anatomical proportions and fundamental characteristics of Seinen. Unlike other Manga styles and genres, its figures are not dominated by huge eyes and other exaggerated physiological features.

- Soft pencil (2B)
- Eraser
- Regular paper (80-120gsm)

1 Creating the structure

Start off by making a very rough sketch but be sure to accurately represent the pose with your axes, perspective and action line. This will serve as the foundation over which you will construct your Yakuza and will also help you to place and scale his figure on your paper.

2 Creating volume

Use circles and ovals to indicate different sections: the skull, jaw, abdomen, shoulders, limbs, and so on. Strengthen your axis lines and refine perspective ready to add detail later.

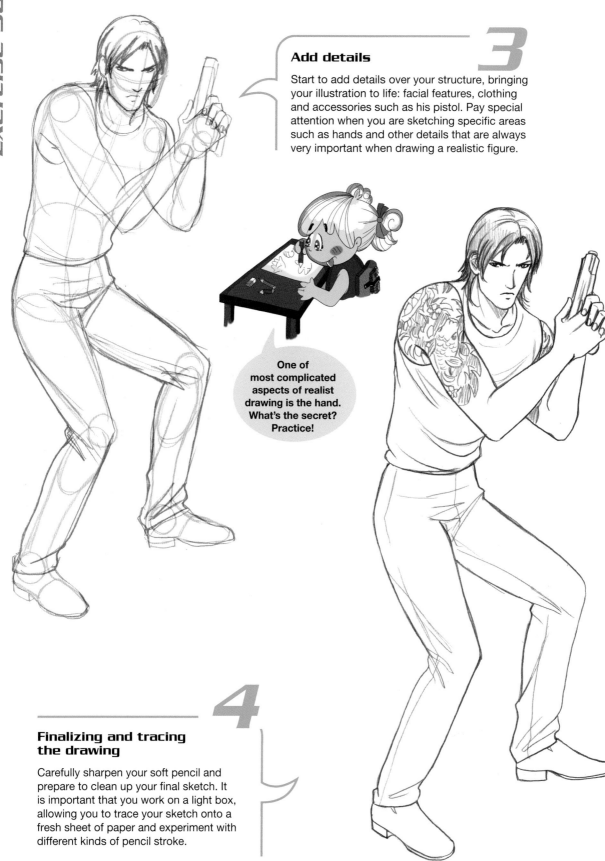

Add details

3

Start to add details over your structure, bringing your illustration to life: facial features, clothing and accessories such as his pistol. Pay special attention when you are sketching specific areas such as hands and other details that are always very important when drawing a realistic figure.

One of most complicated aspects of realist drawing is the hand. What's the secret? Practice!

Finalizing and tracing the drawing

4

Carefully sharpen your soft pencil and prepare to clean up your final sketch. It is important that you work on a light box, allowing you to trace your sketch onto a fresh sheet of paper and experiment with different kinds of pencil stroke.

Policewoman

While Seinen is fundamentally aimed at a male audience, its feminine counterpart, Josei Manga, typically features adult females as its main protagonists. This exercise again presents a static pose, allowing you to introduce details and familiarize yourself with this style. Do not forget to take great care when drawing in the axes on which you will structure your figure, as these will affect its overall success.

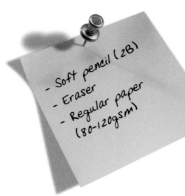

- Soft pencil (2B)
- Eraser
- Regular paper (80-120gsm)

1

Initial sketch

Mark axes and volumetric lines for each part of the character. Remember that this is a first-draft version and details will be added later. It is, however, important to proportion and pose the character correctly.

Exercise 31

2

Constructing the character

Define the character's overall volume, taking care to correctly proportion different areas. If necessary, reposition your perspective axes, over which you will later add details.

3

Sketching details

In this phase you should draw details over your structure: the character's cap, hair, eyes, nose, mouth, uniform, hands and all her different accessories, which you should take some time to research beforehand.

4

Finalizing figure

Thoroughly check the overall volume and structure. Try to decide which of your pencil lines are necessary and which are superfluous. You can still enhance and finalize details at this late stage.

Classic Seinen salaryman

Japanese everyday life and customs are integrated into many Seinen storylines. The 'salaryman' is an office clerk who talks about his marital and workplace woes and the strained relationship that he often has with his superiors. In this exercise we will take a closer look at some of his most characteristic features at the end of a busy working day. Often these characters do not have an oriental physiognomy. This is a pencil-based exercise centred on constructing the volume and structure of the figure first.

- Soft pencil (2B)
- Eraser
- Regular paper (80-120gsm)
- Optional: superior quality paper (about 120gsm)

1 Structuring your character

Create a sketch that sets your character's dimensions to the size of your paper. Mark in the different axes and indicate proportion by suggesting volume.

2 Carefully establishing volume and proportions

Although this figure's pose is static, it presents a three-quarter view (that is to say, somewhere between a frontal and side-on view) so take care when representing this subtle perspective. As you create the shape, take into account that the torso is angled slightly, so reflect this in its proportional axes.

Exercise 32

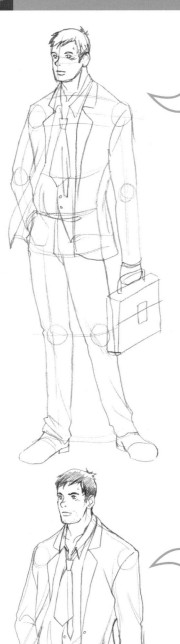

Placing initial details

Sketch in details such as the character's briefcase, clothing and facial expression. These can all be enhanced later, but for now just outline them and make sure they are correctly located.

3

> You can create your first-draft sketch with a red coloured pencil and then add details in black.

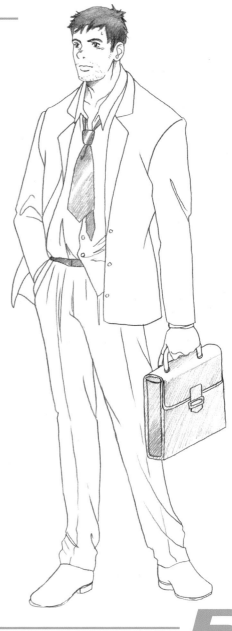

Add definition and detail

Outline, refine and finish placing the remaining details on the same piece of paper. Now your figure should be properly defined and ready for tracing; check all your pencil strokes carefully before moving on to step 5.

4

5

Tracing

Place a fresh sheet of paper (superior quality and 120gsm or less) over your completed sketch. Secure it to the sketch at all four corners with adhesive tape, place it on your light box and trace over the image; your pencil strokes must be bold and confident. When working on the hatched (criss-cross shaded) areas, you can angle your pencil lead or work with one of its sides using quick, subtle parallel strokes.

Ninja warrior

Here you will draw a figure in an action pose and finish with an ink-fill technique. The intention is that your work begins to take on a more professional appearance, enabling you to prepare illustrations worthy of publication in a Manga comic book. This warrior is armed with a katana (sword) and a shuriken (throwing star), essential for any self-respecting Ninja.

Character design

Your first step is to establish the figure on its axes before creating volume and defining the size and perspective of different parts of his anatomical structure.

1

- Soft pencil (2B)
- Eraser
- Regular paper (for sketch)
- Round-tipped, fine medium paintbrush
- Black Indian ink
- Good quality silk-coated paper (for inking)
- White gouache

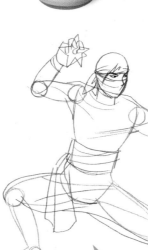

2

Sketch the figure

Sketch accessories and other details. To do this, make initial pencil strokes to roughly suggest details that identity the figure and give it personality and strength. Sketch their shape and volume over your perspective axes.

Exercise 33

Tracing in pencil

Trace over a backlit surface whenever you can; this will help you to make bold and definitive pencil strokes. If you make any errors at this stage that cannot be corrected with an eraser, it may be easier to trace the image afresh onto a new sheet of paper. You can, of course, produce many different copies of your illustration from your original sketch.

Inking lines

You should be brave enough to work in quill pen or paintbrush, as these result in a better finish than marker pen. Again, work over a backlit surface and use the best quality silk-coated paper that you have, preferably 120gsm. Concentrate on maintaining an even brush stroke so that you can get the best out of this medium.

4

3

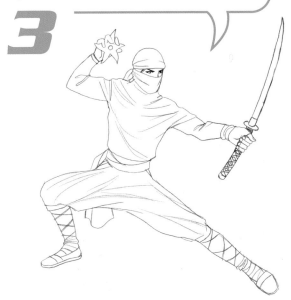

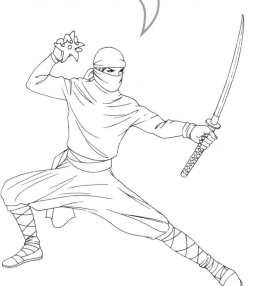

5

Creating light and shade

Decide where to light and shade each area of your character, giving it three-dimensionality and volume. Fill black areas with your paintbrush and create highlights by leaving the white of the paper in places. Any errors that you make in this ink-fill step can be corrected with the help of the white gouache, or you can carefully scratch away small areas with a scalpel.

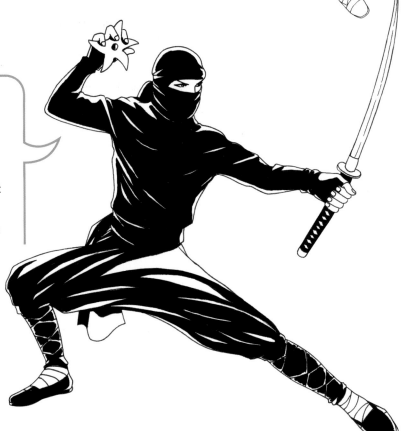

Ronin student

This is essentially a further exercise in inking, but for the first time we add in a very simple background. The important thing is to place your figure over this background and create a single, convincing illustration that successfully integrates both elements. Here we will apply our ink finish with marker pens of different thicknesses. Our character is a 'Ronin', a student attending a preparatory school in his attempts to graduate to college, where he has all kinds of adventures and misadventures.

- Soft pencil (2B)
- Eraser
- Regular paper (for pencil sketch)
- Marker pens with 4mm and 8mm felt nibs
- Paper to trace onto (120gsm)
- Ruler

1 Constructing the character and adding volume

Focus on the character's pose, volume and proportion. Remember that this step is not strictly a drawing but rather a planning stage, although you must still be skilful with a pencil to achieve the desired results.

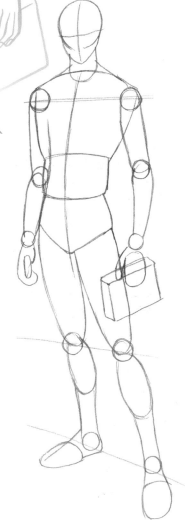

Exercise 34

Add background details

The full bookshelf in the background complements this character well and helps to place him in his proper context. Draw and sketch using long pencil strokes, paying particular attention to perspective so that the figure has depth and does not appear flat, despite its simplicity.

Draw details

Use a soft pencil to add details, then outline your sketch, clearly define its forms and volume and generally improve the character's overall structure. Begin to fill in background details and, above all, make sure that the perspective is correct and creates a sense of depth.

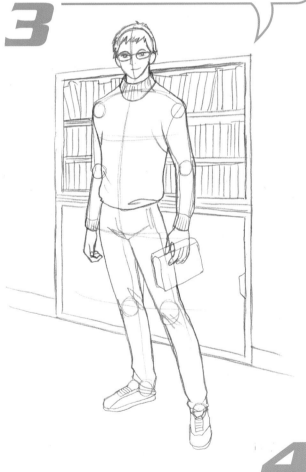

Tracing your sketch

Carefully trace your sketch in soft pencil. During this pre-inking phase, you should finish defining the character's details (repositioning them if necessary) and make sure that you can see your definitive sketch among the lines of your draft sketch. The result will be a perfect finish that only differs from your final illustration in technique, in this case inking.

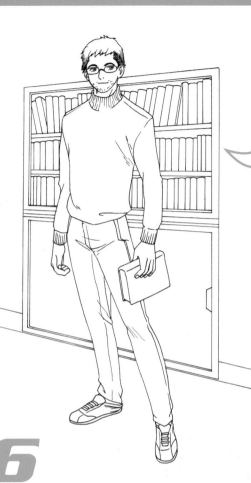

5

Inking lines

If you complete this step in marker pen, it will be much easier to achieve the desired result. Ink both the character in the foreground and the background with your 4mm felt-tipped marker, attempting to keep your pen strokes clean, firm and uniform. You can always use a ruler to help you draw straight lines.

6

Inking the outline

Continue by re-inking only the outline of your figure (not the background), this time with the 8mm marker pen, again ensuring your lines are uniform. In this way the figure will stand out against the background, as the difference in thickness between the lines in the foreground and background give the illustration depth.

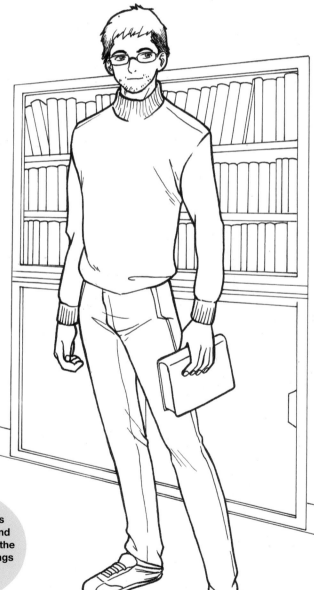

Use fine-tipped marker pens to ink the background and thicker ones for the foreground. This brings depth to your illustration.

Office secretary

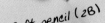

- Soft pencil (2B)
- Eraser
- Regular paper (for pencil sketch)
- Quill pen
- Black Indian ink
- 120gsm silk-coated paper (for inking)
- Adhesive screentones
- Scalpel
- Fine-tipped round paintbrush
- White gouache

This is another character typical of Josei Manga, or Manga for an adult female audience, which can also be referred to as Redisu or Redikomi Manga. Its graphic and narrative styles are more realistic than the Shoujo genre, which tends towards a more idealized form. Josei plot lines range from stories about young university students to housewives and working professionals. In this exercise you will apply screentones to your character, creating interesting halftone effects.

1

Creating volume and perspective

Structure your character around her reclining pose, establish volume and sketch in background detail. Always consider perspective as you work, even when it is as subtle and discreet as it is here; this will greatly enhance the sense of depth in your illustrations.

Adding details

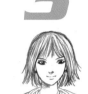

Incorporate facial features, details and other necessary elements over your structure. Develop the outline of the figure, trying to create a sketch that is as close to your finished drawing as possible.

Outline and perfect the pencil drawing

Carefully outline the entire figure, makings details strong and more expressive. Always keep your pencil sharp. We recommend that you become accustomed to working with a light box: it will help you when tracing over sketches and inking finished figures, and it has many other applications that you will discover through frequent use.

Eyes

Realistic Seinen-style eyes

Seinen characters' eyes are not filled with pools of light or as large as they are in other Manga styles. Their structure leans heavily towards realism and sometimes they are clearly Oriental in appearance. Follow the usual steps: create a preliminary sketch to define structure and expression, then draw in details and outline your work.

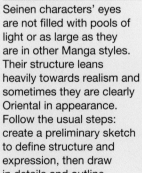

Inking the figure

Try outlining your figure with Indian ink and a quill pen. Use silk-coated paper as its smooth surface makes it easier to apply a sure, even stroke. You can perfect your work with a quill pen by keeping a fresh piece of paper handy to experiment on, a cotton cloth and plenty of water to occasionally clean its nib.

Exercise 35

5

Applying the first screentones

There are many different types of textured screentone available; choose some that are best suited to your subjects. Use a very sharp scalpel to cut one of these screentones to the size of the area that you want to fill. Fix the finished section to your figure by placing a clean sheet of paper on top of the screentone and apply slight pressure with the palm of your hand, so that air bubbles do not form between the screentone and paper surface. Use your scalpel to remove any excess screentone, taking care not to damage the paper underneath. Repeat this procedure with different types of screentone.

6

Creating light and volume

You can use the scalpel to remove sections of screentone where you wish to show that light is falling, or paint over screentones in white gouache. A really important part of this step is to have a clear idea of the direction from which your subject is lit and that its volume is logical and consistent.

7

Superimposing screentones to create effects

You can begin to explore the infinite possibilities offered by screentones by layering one over another, creating intriguing and attractive visual effects. Here we superimpose screentones in order to obtain different levels of tonal intensity (for example, on her skirt). Conversely you bring relief to the figure by using your scalpel and white gouache to create highlights.

Attacking Samurai

In this exercise we introduce a highly attractive and rewarding colouring technique. You will use watercolour pencils, which are easy to use, economical and can produce spectacular finishes if correctly applied. The character you will be working on is a legendary Samurai in an all-action pose. Structure this figure carefully because its representation must be balanced and solid. This will also help you to apply colour, as despite its apparently minimal colour scheme, it must create the impression of great strength.

- Soft pencil (2B)
- Eraser
- Regular paper (for pencil sketch)
- Sepia and black waterproof marker pens
- Watercolour pencils
- Medium round paintbrush
- Watercolour paper

Finishing in pencil

1

We will skip the usual preparatory steps because this is primarily a colouring exercise. Remember to use your pencil strokes to correctly finish and detail the figure so that inking is a simple task.

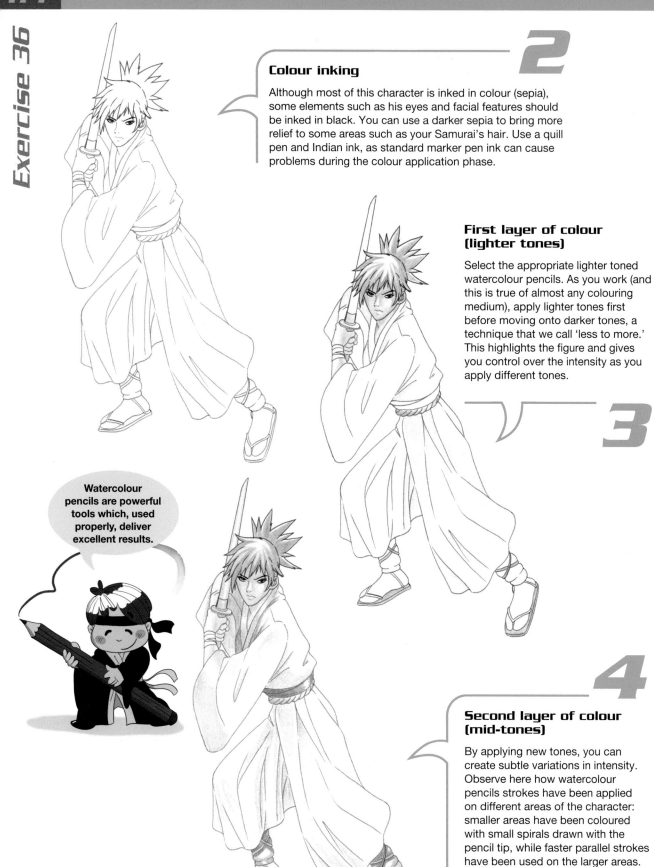

2
Colour inking

Although most of this character is inked in colour (sepia), some elements such as his eyes and facial features should be inked in black. You can use a darker sepia to bring more relief to some areas such as your Samurai's hair. Use a quill pen and Indian ink, as standard marker pen ink can cause problems during the colour application phase.

First layer of colour (lighter tones)

Select the appropriate lighter toned watercolour pencils. As you work (and this is true of almost any colouring medium), apply lighter tones first before moving onto darker tones, a technique that we call 'less to more.' This highlights the figure and gives you control over the intensity as you apply different tones.

3

Watercolour pencils are powerful tools which, used properly, deliver excellent results.

4
Second layer of colour (mid-tones)

By applying new tones, you can create subtle variations in intensity. Observe here how watercolour pencils strokes have been applied on different areas of the character: smaller areas have been coloured with small spirals drawn with the pencil tip, while faster parallel strokes have been used on the larger areas.

Exercise 36

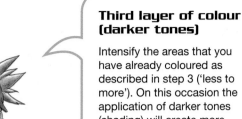

Third layer of colour (darker tones)

Intensify the areas that you have already coloured as described in step 3 ('less to more'). On this occasion the application of darker tones (shading) will create more contrast with brighter areas, thanks to their interaction with the white of the paper and your first layer of lighter tones.

5

Enhancing the pencil drawing

6

Choose an area of your character that you wish to enhance. Here we refer you to the collar and sleeve trims of his kimono, his belt, and so on. These splashes of vivid yellow bring a greater level of contrast to the figure.

7

Watercolour effects

Don't get your watercolour pencil too wet; just dampen the tip, check if it is wet enough (perhaps on scrap paper) and load it with more water as required. Work carefully and methodically from area to area according to colour, and never apply more than one layer or colours will run into each other and smudge. The idea is to apply water as if it were paint.

Soldier of fortune

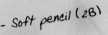

- Soft pencil (2B)
- Eraser
- Regular paper (for the pencil sketch)
- Fine-tipped round paintbrush or quill pen with Indian ink, or waterproof marker pens
- Aniline dye or watercolour paint
- Medium round watercolour paintbrush
- Watercolour paper
- White gouache

Here we will work extensively with watercolours; you can work with standard watercolours that come as blocks or in tubes, or with aniline dyes. The fundamental difference is that there is a wider range of aniline dye colours on the market, but you could always acquire a few basic colours and mix your own tones. Another consideration is that aniline dyes usually provide a more vivid finish; ultimately it is your decision and will depend on the effects that you wish to apply to your illustrations.

Draw the character in pencil

Sketch, draw and detail your character. Ink its lines very carefully. Remember always to work with a very sharp pencil.

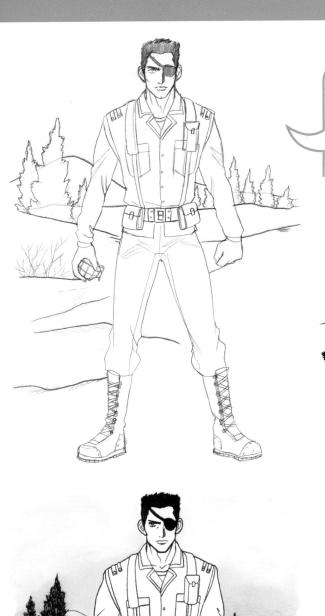

2 Drawing the background in pencil

We will create a simple background on which to centre our soldier. Using finer pencil lines when drawing this background will result in a greater sense of depth in the illustration as a whole. This effect can be enhanced during the inking process.

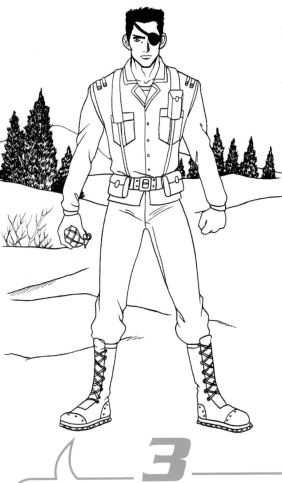

3 Inking the drawing

Ink both the figure and background in Indian ink with either a quill pen or paintbrush. While waterproof marker pens could also be applied here, note that it is very important to master different mediums.

4 First background layer: lighter tones

In Exercise 36 we saw the importance of working 'less to more,' and as you are working towards the foreground here, start by applying lighter colours to the background.

First character layer: lighter tones

5

Applying the character's lighter colours will give you an overview of the composition and help you when building up further layers of colour, particularly when creating volume and applying highlights.

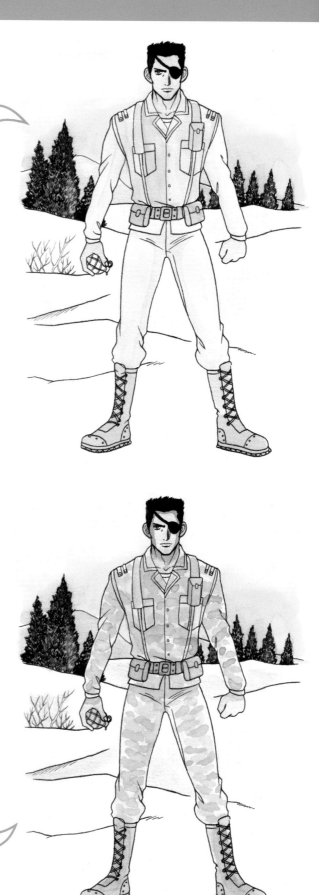

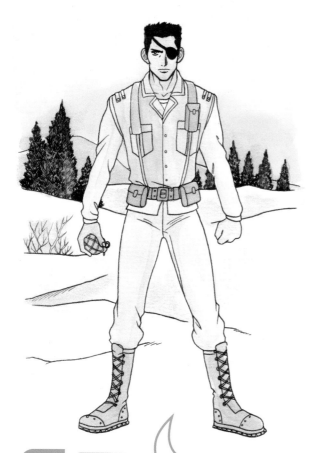

6

Second background layer: mid-tones

Paint the snow closest to the figure using a slightly darker tone than before, conveying the feeling that this part of the background is closer to the figure.

7

Second character layer: mid-tones

Begin to shade the face, boots and other areas, enhancing your character's overall tonal intensity. Create the uniform's dappled camouflage effects by loading your brush heavily with paint and daubing it onto the paper (rather than using brushstrokes).

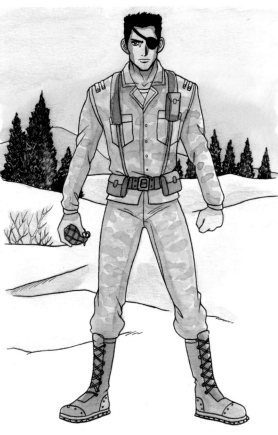

8

Adding darker tones to the character and background

Using darker colours, apply a new layer that highlights the character's shading and adds tone to the sky. Review all of your shaded areas and intensify them, enhancing the illustration's three-dimensionality.

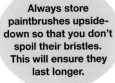

Always store paintbrushes upside-down so that you don't spoil their bristles. This will ensure they last longer.

9

Retouching and finishing

With a clean paintbrush and a little white gouache, redefine the edges of any overlapping areas of colour, aligning them with the character's contours. Finally, paint a cast shadow at the character's feet; this establishes his position in relation to the ground.

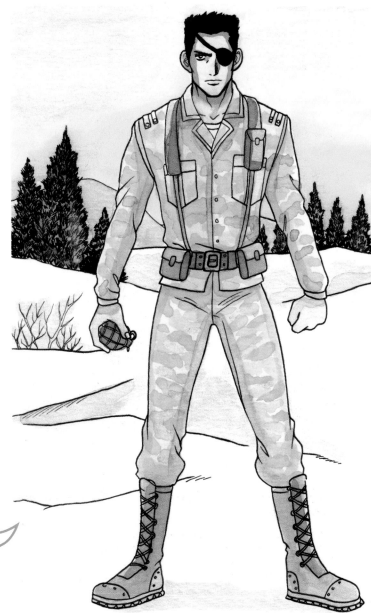

All-action superheroine

I n this exercise we will show you how to colour with marker pens, one of the most common mediums across all styles of Manga illustration. Markers allow you to work rapidly and once you have mastered them, you will be able to colour large areas quickly. We recommend special markers that do not leave individual stroke marks; these are a clean medium that can deliver brilliant, vivid finishes. The downside is that they are not cheap, but there are many reasonably priced brands that deliver excellent results.

- Soft pencil (2B)
- Eraser
- Regular paper
- Fine-tipped round paintbrush or quill pen for inking
- Indian ink
- Coloured marker pens (Copic or a similar brand)
- Colourless marker pen (blender) to dilute ink
- Paper for final illustration (120gsm)
- White gouache

Pencil drawing

Prepare the usual pencil drawing, ensuring that the figure is perfectly placed, outlined and proportioned.

1

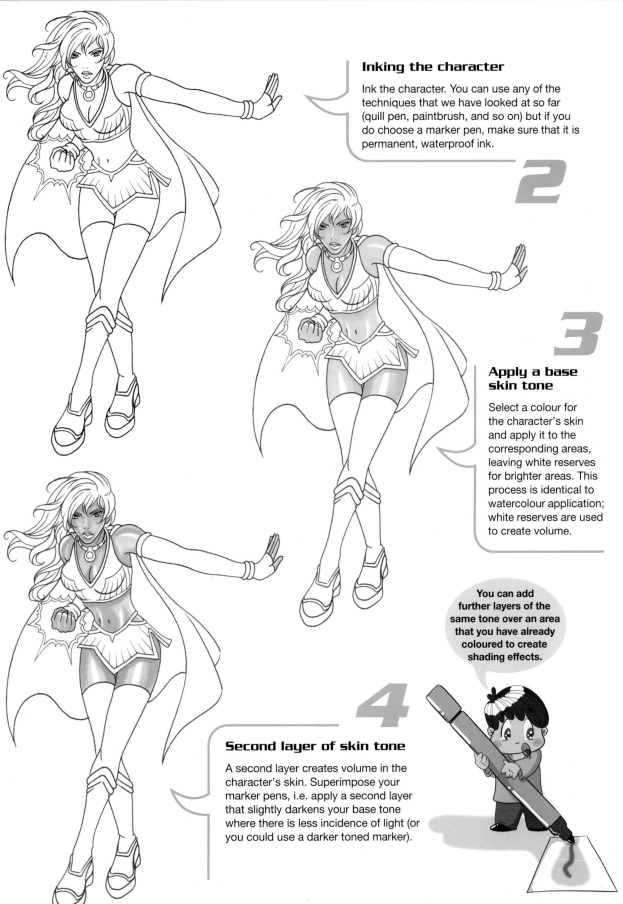

Inking the character

Ink the character. You can use any of the techniques that we have looked at so far (quill pen, paintbrush, and so on) but if you do choose a marker pen, make sure that it is permanent, waterproof ink.

2

3

Apply a base skin tone

Select a colour for the character's skin and apply it to the corresponding areas, leaving white reserves for brighter areas. This process is identical to watercolour application; white reserves are used to create volume.

You can add further layers of the same tone over an area that you have already coloured to create shading effects.

4

Second layer of skin tone

A second layer creates volume in the character's skin. Superimpose your marker pens, i.e. apply a second layer that slightly darkens your base tone where there is less incidence of light (or you could use a darker toned marker).

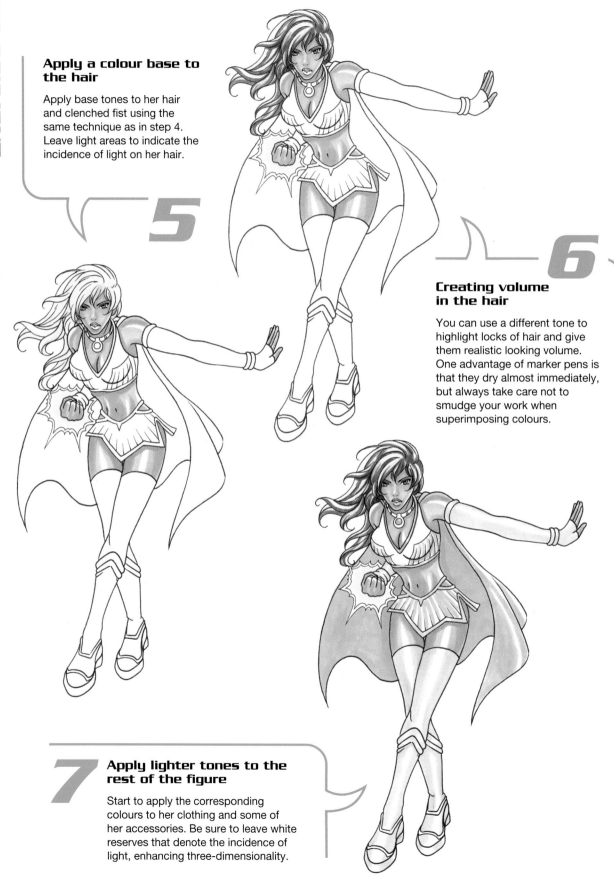

Apply a colour base to the hair

Apply base tones to her hair and clenched fist using the same technique as in step 4. Leave light areas to indicate the incidence of light on her hair.

5

6

Creating volume in the hair

You can use a different tone to highlight locks of hair and give them realistic looking volume. One advantage of marker pens is that they dry almost immediately, but always take care not to smudge your work when superimposing colours.

7 ### Apply lighter tones to the rest of the figure

Start to apply the corresponding colours to her clothing and some of her accessories. Be sure to leave white reserves that denote the incidence of light, enhancing three-dimensionality.

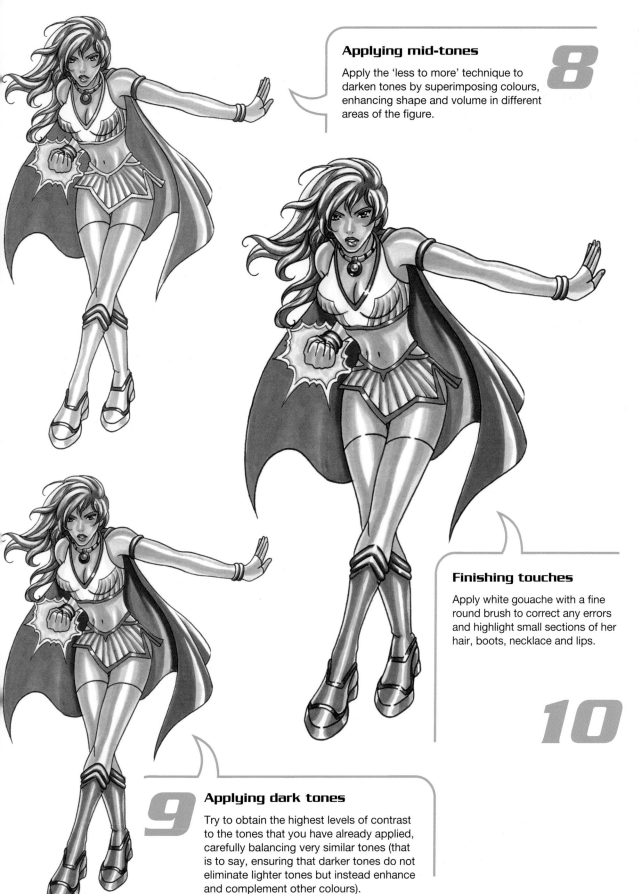

Applying mid-tones

Apply the 'less to more' technique to darken tones by superimposing colours, enhancing shape and volume in different areas of the figure.

8

Finishing touches

Apply white gouache with a fine round brush to correct any errors and highlight small sections of her hair, boots, necklace and lips.

10

9 **Applying dark tones**

Try to obtain the highest levels of contrast to the tones that you have already applied, carefully balancing very similar tones (that is to say, ensuring that darker tones do not eliminate lighter tones but instead enhance and complement other colours).

Bounty hunter

The computer is an indispensable tool for any illustrator, regardless of the style or technique in which they work. A digital graphics program puts an infinite variety of techniques at your fingertips, and the results it delivers would be the envy of any artist working in traditional ways. Working digitally will also save you money in the long term, because you will not need to buy lots of art materials once you have made your initial investment. While you may have to pay to use professional-grade software, there are many free applications available. Their tools are very similar, so choose whichever is most suited to your needs or budget; just learn how to use them and your artistic instincts will do the rest.

1 Pencil drawing

Create your sketch and give it volume. Draw in all the details and then trace the figure as in previous exercises.

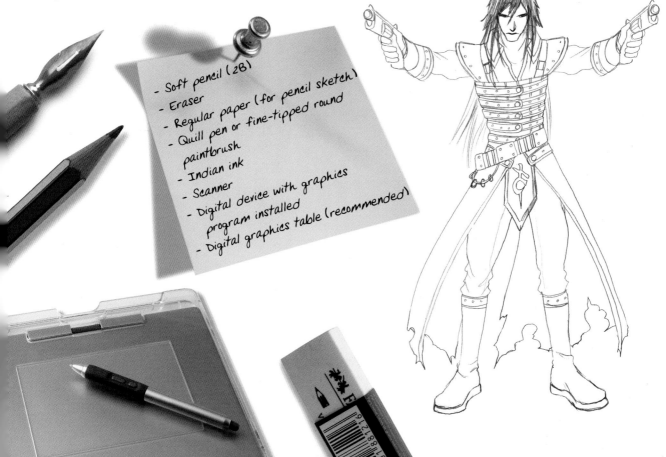

- Soft pencil (2B)
- Eraser
- Regular paper (for pencil sketch)
- Quill pen or fine-tipped round paintbrush
- Indian ink
- Scanner
- Digital device with graphics program installed
- Digital graphics table (recommended)

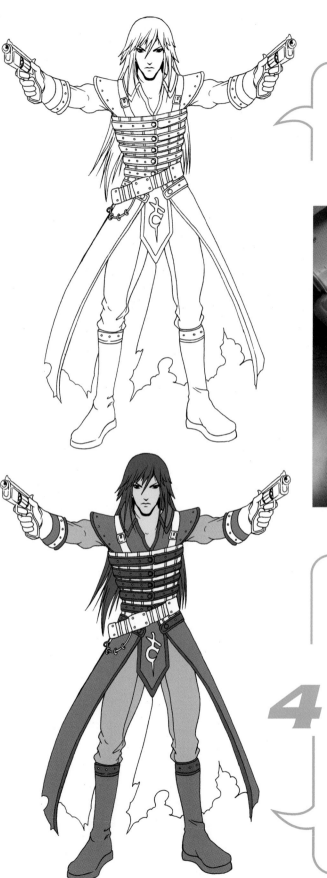

Inking the drawing

Place the paper over a light box and ink the drawing with any of the techniques that we have studied up to this point. Ensure that your original is as clean as possible before placing it on the glass of your flatbed scanner.

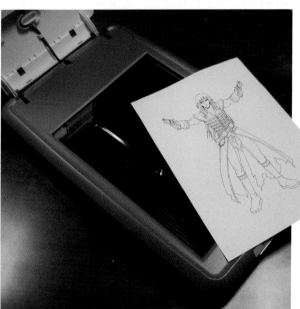

Scan the drawing

Scan your illustration at 300 dpi or higher for the best results. Use grayscale at this stage to ensure the best quality lines.

Applying the first colours

To apply colour, you must first assign your image either RGB or CMYK values: RGB if your work is going to appear onscreen (web, blog, and so on) or CMYK if you plan to circulate your artwork via any print media. Choose the appropriate colour value from the palette, then use the 'magic wand' tool to select the areas where you are going to apply spot colours. Use the 'paint fill' tool and repeat this process on other areas of your bounty hunter's body. Remember that it is always possible to backtrack and undo a step if you are not happy with the result.

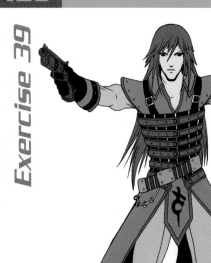

5

Complete the figure's colour base

Continue by using the 'magic wand' tool to select individual areas, and apply colour with the 'paint fill' tool. A specific area will be filled with colour automatically (as long as it is perfectly outlined and enclosed).

6

Shading

This procedure will vary depending on the graphics program you use, but shading is normally applied as a new layer using your software's 'multiply' mode. Select the areas you wish to shade with the 'magic wand' tool and colour them in a darker tone with the 'airbrush' tool or one of the various 'paintbrush' tools.

7

Adding lighter tones

Select different areas of your illustration with the 'magic wand' tool and activate your software's 'divide' mode to apply a new layer of lighter tones; follow the same procedure detailed in step 6. Apply the same tone as your base layer; notice how your software automatically filters and lightens colours.

You will find many tutorials and tips on the internet which will help you to become proficient at using digital artwork software.

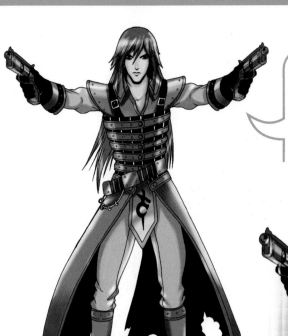

Applying effects to skin tones

8

Now you can combine all the layers and apply the skin tone effects studied in previous exercises. Try to ensure that shading and highlights on the character's face are consistent with those on the rest of the figure. Use this step to redefine smaller details: eyes, hair and certain lighting effects.

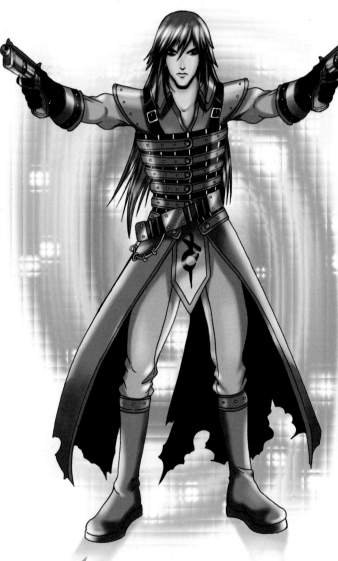

Create an abstract background

Sometimes a background is not much more than a tone that enhances a figure's colour scheme and complements the image as a whole. You can create the background seen here with spot colours and then apply filters such as 'spiral blur' and 'glass'. In fact, you can use any combination of filters that you like if they result in an attractive overall effect. Finish off by adjusting colour values, giving your character more depth.

9

10

Finishing touches

Open the background image and character illustration so they display onscreen. Select the white area of the 'paper' to separate it from your character, which you can then drag onto the background. Finally, adjust parameters (brightness, contrast, saturation, and so on) to complete your character.

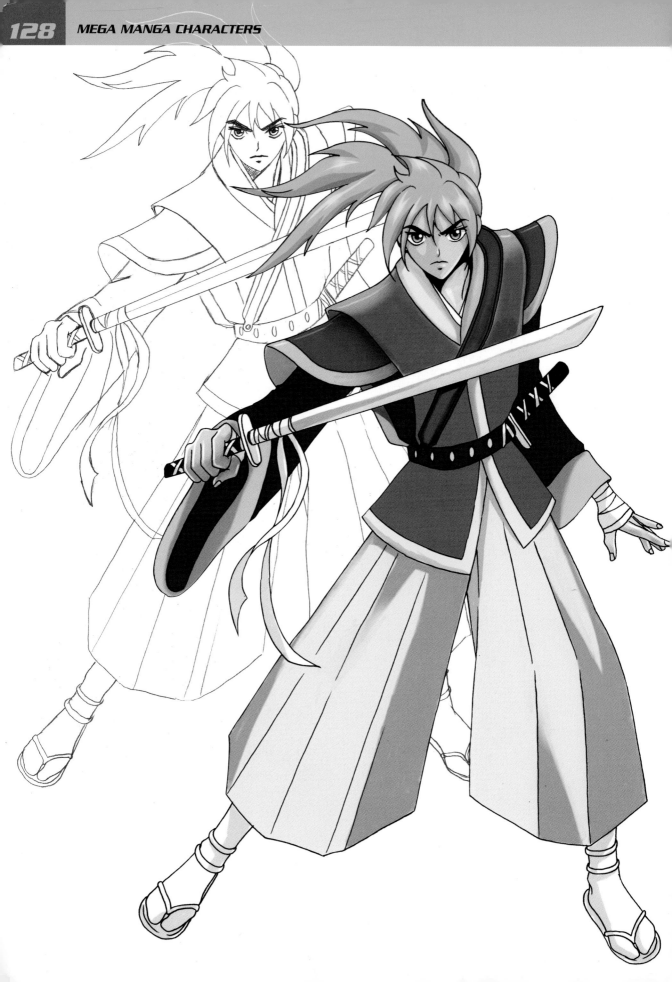